WITHDRAWN

LIVERPOOL JOHN MOORES UNIVERSITY
Aldham Robarts L.R.C.
TEL: 0151 - 231- 3179

D1422528

FABR

19

COOL
HOT
COLORS

JOY SHIH

Schiffer Publishing Ltd

4880 Lower Valley Road, Atglen, PA 19310

LIVERPOOL JMU LIBRARY

3 1111 00768 1990

Books are to be returned on or before
the last date below.

-5 DEC 2001 9 OCT 2004

19 MAR 2002 25 NOV 2004

9 MAY 2002

30 MAY 02

18 NOV 2002

18 FEB 2003 -7 FEB 2006

-2 MAY 2003

 28 FEB 2006

11 NOV 2003

19 FEB 2004

LIBREX

30

DEDICATION

For my cool nieces,
Carol, Judy, and Angie,
Corin Joy and Lori Lyn,
Jana and Cara,
Chandra and Ashanti.

And my most beautiful creation, Lauren Lisa.

LIVERPOOL JOHN MOORES UNIVERSITY
LEARNING SERVICES

Accession No
AB005634K

Class No 746.09046 SHI

| Aldham Robarts 0151-231-3701 | √ | ..m Street 0151-231-2329 | |
| I M Marsh 0151-231-5216 | | Trueman Street 0151-231-4022 | |

Copyright © 1997 by Schiffer Publishing
Library of Congress Catalog Card Number: 97-80091

All rights reserved. No part of this work may be reproduced or used in any form or by any means—graphic, electronic, or mechanical, including photocopying or information storage and retrieval systems—without written permission from the copyright holder.

Book design by: Blair Loughrey

ISBN: 0-7643-0342-2
Printed in Hong Kong

Title page photo: Small print of trailing vines and flowers in a stylized pattern. Mint green, jade green, gold, and white on black. Rayon. Italian. 1966.

Published by Schiffer Publishing Ltd.
4880 Lower Valley Road
Atglen, PA 19310
Phone: (610) 593-1777
Fax: (610) 593-2002
E-mail: schifferbk @ aol.com

Please write for a free catalog.
This book may be purchased from the publisher.
Please include $2.95 for shipping.
Try your bookstore first.

We are interested in hearing from authors with book ideas on related subjects.

CONTENTS

4

INTRODUCTION

Many remember the late 1960s as a time of high energy, social protests, hard-driven music, and a testing-the-limits attitude. If it is true that culture dictates fashion, the fabrics on these pages will provide you with all those feelings. The colors are "cool," the attitude is definitely "hot." And you are invited along for a wild ride through the most fascinating designs intended for a generation that knew no bounds.

Back-to-nature during the late 60s meant flowers, flowers, and more flowers. Although florals have historically been a strong presence in textile design, the late 1960s produced the wildest imaginable renderings of nature's most beautiful creation. Youth culture during that period gave us the term "flower power," alluding not only to the lifestyle of a generation, but to the force of nature. Who can forget the image of a young woman placing a single daisy into the barrel of a soldier's gun to protest the cruelty of war? Flowers were simple joys to a generation experimenting with new social mores.

Designers in the 1960s provided floral images ranging from bold, graphic prints to simple abstracts, from small garden prints to large splashy blooms. The distinguishing feature is the colors. And there are lots of them. The images chosen for this book were selected for the use of "hot" colors: hot pinks, hot orange, neon green, chartreuse, golden yellow, electric blue, aqua, turquoise, purple, and fuchsia. Some designs are primarily in colors not considered "hot" but which have splashes or streaks of unexpected eye-popping tones. Other designs appear soft or "cool" yet use a spectrum of

"hot" shades in a faded look. It is interesting to note that many of the designs use olive green along with the bright colors. Let each page surprise you with the creativity of the designer and the spirit of the person who wore the clothing.

Geometric designs from the late 1960s lend a creative twist to the usual. Polka dots may be set in a typical way but appear in the "hot" colors of the era. Simple checks are printed in hot pink on a puckered nylon fabric. Streaks of color waves are featured on a fabric woven with metallic silver or gold. Plaids have faded into a madras-look watercolor pattern. The influence of artists Peter Max, Mondrian, and Picasso abound in artist-inspired prints. The rule of design during this period is no rule. The free spirit of the 60s gave way to many wonderful designs shown on these pages.

These beautiful fabrics are taken from actual textile manufacturers' pattern books from 1966-1969. It is apparent from these samples that the cool "hot" colors of the era went beyond America. The designs are from fashion textile "houses" in Milan, Italy, Paris, France, and New York. The fabric content indicates that these were designer or couture creations in luscious silks, rayons, linen, and cotton. Many of the swatches are small and do not show repeats but the overall design is described or shown if known. Dates in the description complete the information.

A wonderful world of really cool "hot" colors awaits you. Experience the late 60s with each of the glorious designs created to bring out the spirit of a generation.

FLORALS

Top: Graphic image of stylized flowers and French curve leaves. Hot pink, bright yellow, orange, purple, grass green, and emerald green. Textured twill weave cotton. Italian. 1968.

Center: Bold colorful shapes form large flower petals in the overall design. Linen and silk. French. 1969.

Lower: Stylized floral print. Hot orange, lime green, and bright blue on hot pink. Textured twill weave cotton. Italian. 1968.

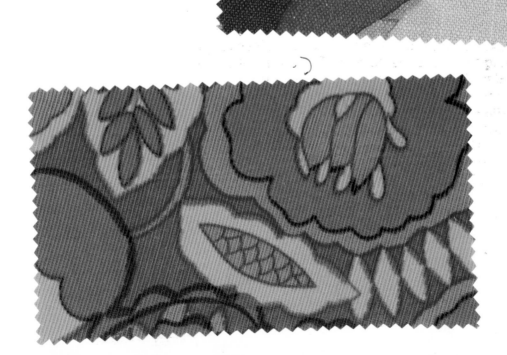

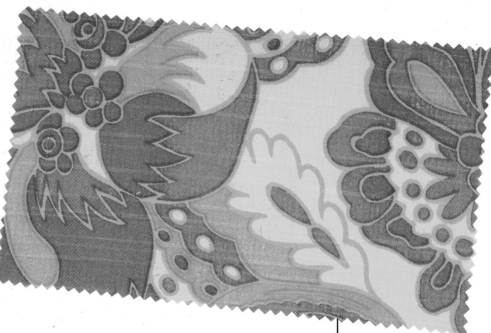

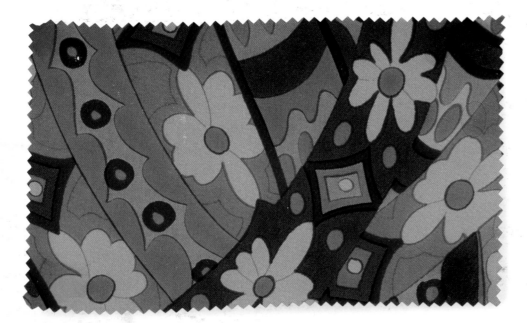

Above: Very hot neon colors in a psychedelic floral print. Bright yellow, hot orange, and shocking pink. Cotton and linen. Italian. 1969.

Top left: Bright vegetable print in hot orange, red, pink, hot pink, light jade green, bright lime green, and olive green. Heavy twill weave cotton. Italian. 1968.

Lower: Flower power psychedelic design featuring wide curving bands. Hot orange, shocking pink, lavender-pink, turquoise, blue, and black. Silk. Italian. 1969.

Top: Graphic tulip design. Peacock blue, bright blue, yellow, green, red, and black. Silk. American. 1969.

Lower left: Variation in orange, jade, electric blue, aqua, and brown.

Lower center: Variation in shocking pink, orange, fuchsia, bright green, dark blue.

Lower right: Variation in fuchsia, lilac, emerald green, chartreuse, and olive green.

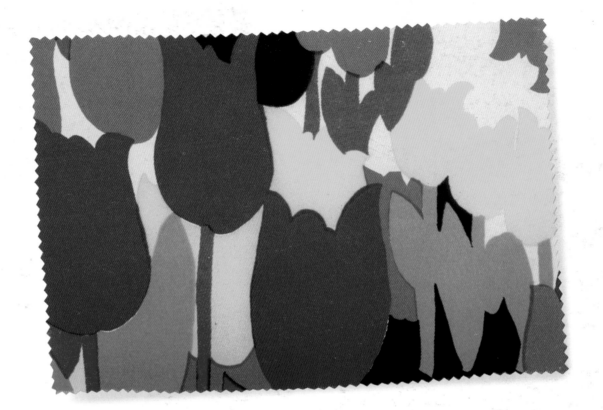

9

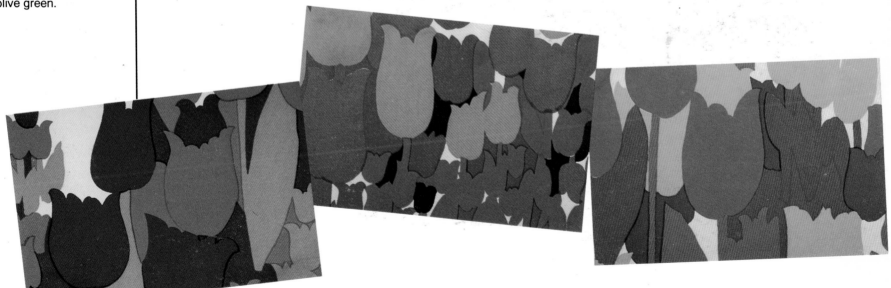

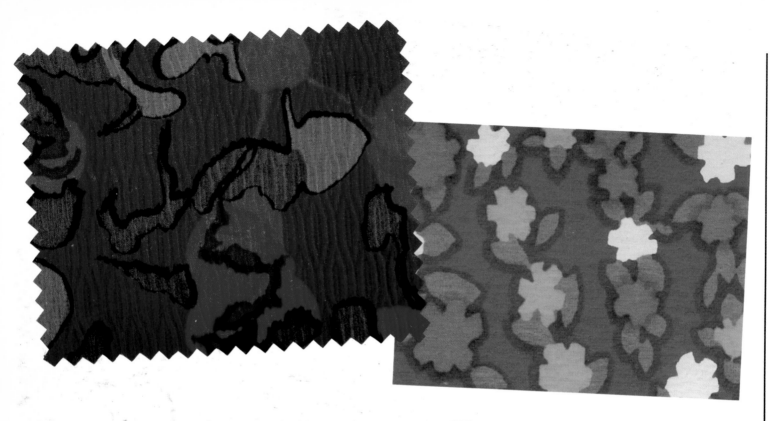

10

Top left: Hot colors in a stylized abstract floral pattern. Hot pink, red, cobalt blue, greens, and black on dark maroon. Silk in a textured birds-eye weave. French. 1969.

Top right: Abstract floral garlands arranged in a modified diagonal stripe pattern. Shocking pink, chartreuse, white, olive and forest green on turquoise. Textured weave rayon and silk. French. 1967.

Lower left: Abstract floral patterns evenly tossed in an interesting design featuring occasional and random open space. Bright yellow, fuchsia, lime green, purple, and white outlined in two tones of olive green, on bright blue. Waffle weave rayon with cotton backing. French. 1967.

Lower right: Patches of color resembling flower petals. Neon green, hot orange, sunflower gold, and purple on beige. Wool crepe. Italian. 1967.

Top: Gently curved petals lend movement to this bright design. Pink, hot pink, blue, green, and tangerine on black. Silk. French. 1968.

Far right: Bold brush strokes in a tulip shape design has a dark brown and black background. This pattern qualifies as "hot" for the unexpected burst of white, bright yellow, hot orange, and hot pink. Silk and rayon. French. 1968.

Lower: Watercolor wash-effect floral pattern. Lime green, light jade, and emerald green. Linen. Italian. 1966.

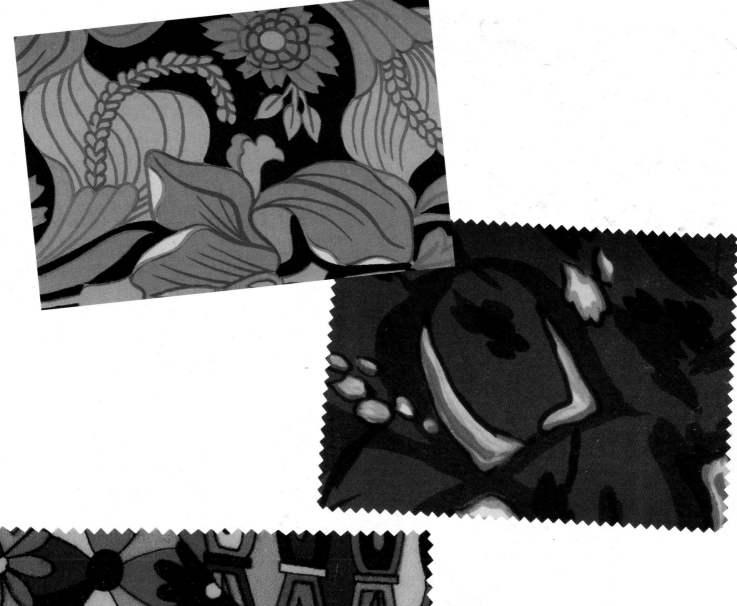

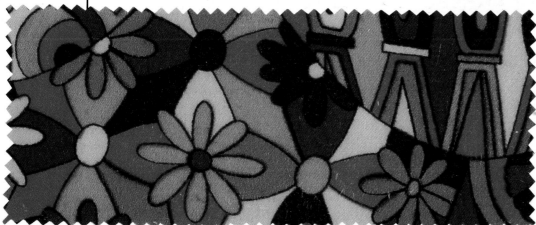

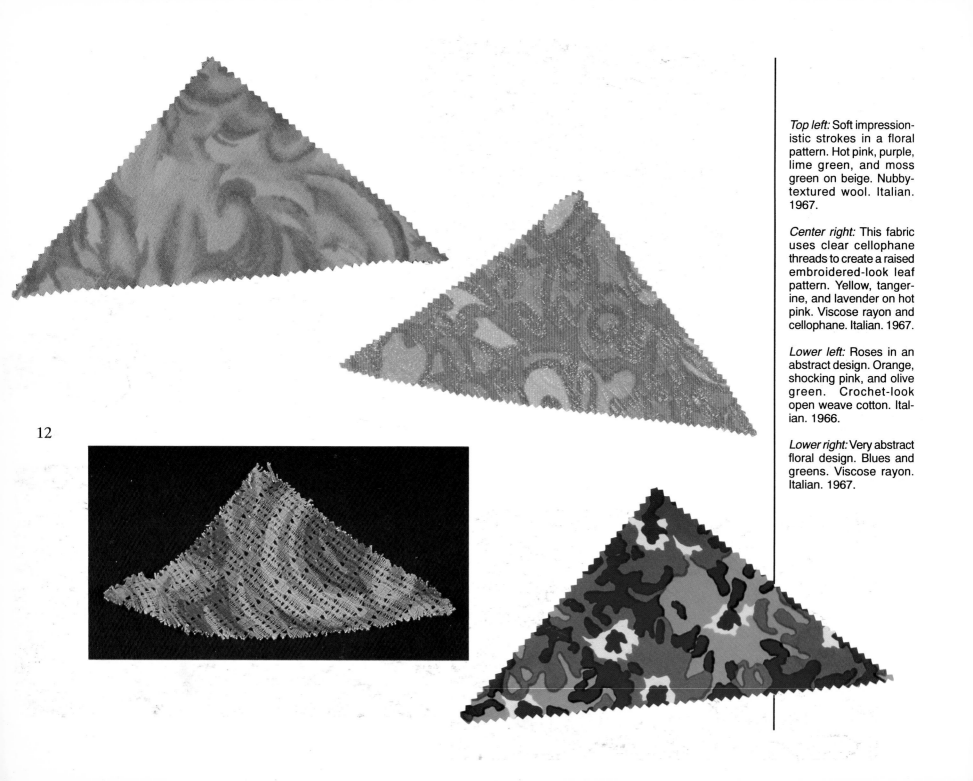

12

Top left: Soft impressionistic strokes in a floral pattern. Hot pink, purple, lime green, and moss green on beige. Nubby-textured wool. Italian. 1967.

Center right: This fabric uses clear cellophane threads to create a raised embroidered-look leaf pattern. Yellow, tangerine, and lavender on hot pink. Viscose rayon and cellophane. Italian. 1967.

Lower left: Roses in an abstract design. Orange, shocking pink, and olive green. Crochet-look open weave cotton. Italian. 1966.

Lower right: Very abstract floral design. Blues and greens. Viscose rayon. Italian. 1967.

Top left: Watercolor-effect splotches of color in an abstract fruit and stem design. Mottled hot pinks and fuchsia on light grey. Rayon crepe. French. 1968.

Far right: Watercolor wash-effect floral pattern. Lime green, light jade, and emerald green. Linen. Italian. 1966.

Lower left: Impressionistic florals with a shiny weave in a grid pattern. Hot pink, purple, orange, neon green, and pale aqua. Viscose rayon and silver lamé with a synthetic backing. Italian. 1967.

Lower right: Gold on gold with a faint floral design. The box weave is crossed with a metallic gold weave. Pale gray and lilac florals on two tones of gold. Viscose rayon and gold lamé. Italian. 1967.

13

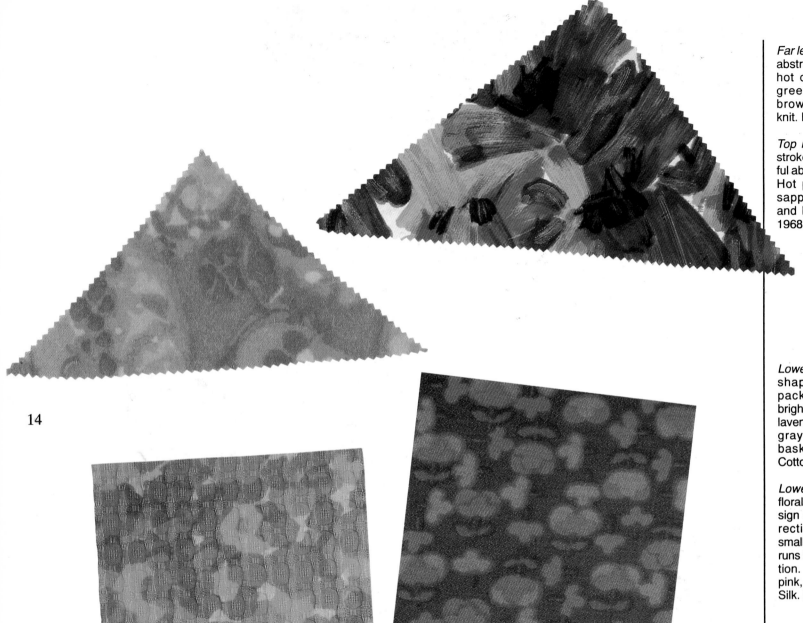

Far left: Soft images in an abstract look. Hot pink, hot orange, pale mint green, and medium brown. Brushed wool knit. Italian. 1967.

Top right: Broad brush strokes create a beautiful abstract floral pattern. Hot pink, red, purple, sapphire blue, green, and black. Silk. Italian. 1968.

Lower left: Abstract floral shapes in an allover packed design. Pink, bright yellow, chartreuse, lavender, light taupe, and gray on white. Fancy basketweave pattern. Cotton. French. 1966.

Lower right: The larger florals in this stylized design lines up in a two-directional pattern. The smaller flowers, however, runs in the opposite direction. Bright orange, hot pink, and aqua on green. Silk. French. 1967.

14

Top: Very small abstract shapes resembles flowers and leaves. Hot orange, bright yellow, red-brown, and greens on black. Silk. French. 1968.

Lower left: Quatrefoil shape flowers and boxes. Hot pink, hot orange, mint green on khaki tan. Rayon. French. 1968.

Lower right: Watercolor-look design vaguely resembling flowers are set in an allover packed tile-effect pattern. Polyester. French. 1967.

15

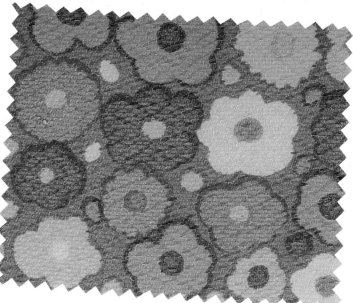

Top left: Very loose interpretation of florals and vines. Hot pink, pale pink, purple, chartreuse, and aqua on medium teal green. Crinkle textured silk. French. 1968.

Top right: Posies and dots in an allover packed design. Yellow, beige, taupe, copper brown, aqua, and purple on hot pink. Woven textured triacetate and polyester. French. 1968.

Lower left: Scallop shapes with the look of flower petals. Hot pink, rose pink, golden yellow, coral peach on olive green. Silk. French. 1968.

Lower right: Abstract shapes in cool tones. Pink, mint green, mustard yellow, light and dark aqua. Pinwale cotton corduroy. French. 1967.

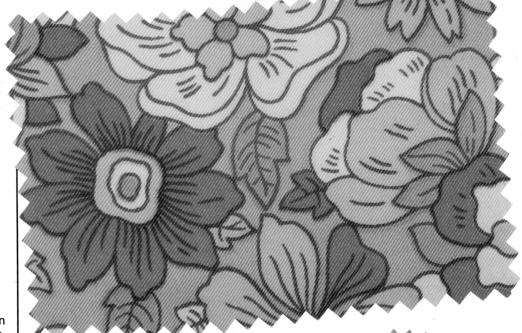

Top: Very hot florals in fuchsia, bright tangerine, yellow, and green on light blue and gray. Note that the blue and gray background fade into each other. Silk. French. 1968.

Lower left: The slightly faded look to the bright florals lend softness to this design. Hot pink, yellow, purple, and green on bright blue. Crinkly silk and rayon with a slight iridescence. French. 1968.

Lower right: Large blooms in hot orange, golden yellow, light and hot pinks on purple. Very sheer silk. French. 1968.

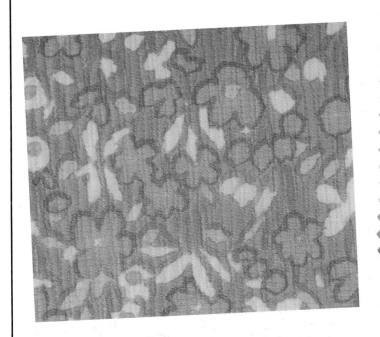

17

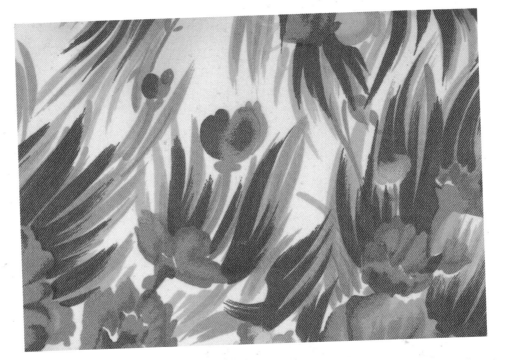

18

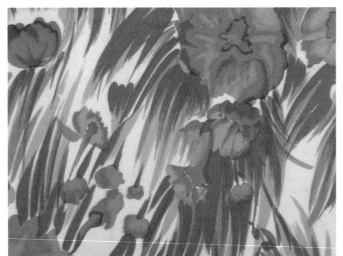

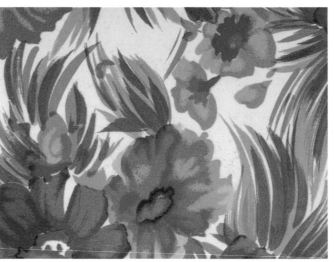

Top: Soft brush strokes in this wildflower print lend gentle movement to the design. Hot pink, hot orange, purple, green, and beige on white. Silk. American. 1968.

Lower left: Variation in aqua, peacock blue, hot pink, lilac, and bright green.

Lower right: Variation in hot pink, hot orange, orange-red, electric blue, aqua and moss green.

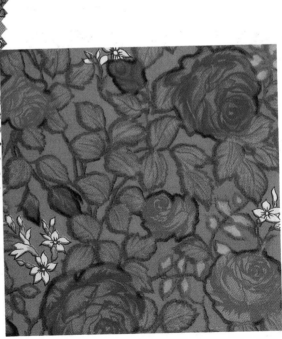

Top left: Florals tightly packed in light pink, hot pink, coral, brown and bright yellow. Heavier weight cotton. French. 1967.

Top right: Field of wildflowers are interpreted in hot pink and hot orange on a leafy background with subtle shades of brown and greens. The field is dark charcoal gray. Rayon and silk. French. 1967.

Lower left: Fine line sketch of garden flowers in an allover packed design. Yellow, tangerine, hot pink, red, taupe-gray, purple, burgundy, brown, and bright green on white. Silk. French. 1968.

Lower right: Beautiful roses and buds in bright coral and fuchsia. Light brown leaves provide a soft contrast to the tiny white flowers. Background is bright blue. Rayon. French. 1967.

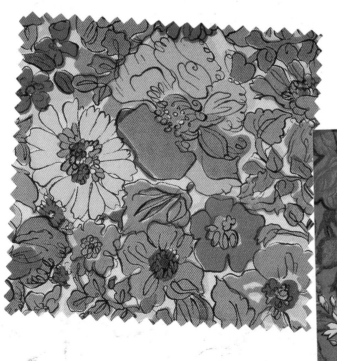

19

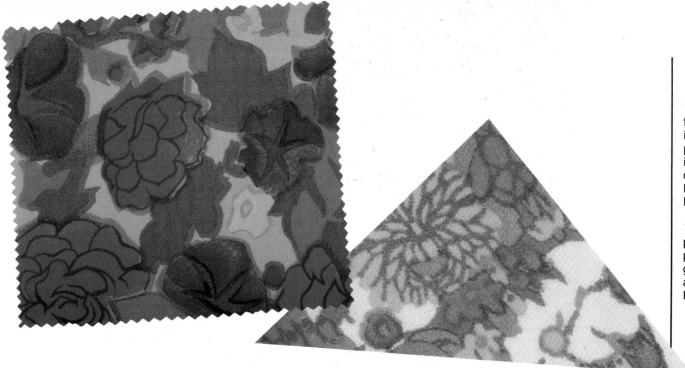

Top left: Watercolor effect of roses and morning glories. Fuchsia, purple, yellow, aqua, olive, and medium green on bright lime green. Polyester and cotton. French. 1967.

Top right: A garden packed with flowers. Hot pink, purple, orange, gold, turquoise, white, and green. Wool knit. Italian. 1967.

Lower left: Graphic interpretation of roses using solid colors and line images. The fabric weave features a cellular design. Hot orange, pink, and white on black. Cotton. French. 1967.

Lower right: Garden setting with various types of flowers. Gold, hot orange, bright green, and purple on white. Wool and rayon. Italian. 1967.

Top: Simple floral shapes in shocking pink, purple, yellow on mint green. Silk. French. 1969.

Lower left: Garden flowers and leafy ferns. Yellow, white, pink, blue, and green on aquamarine. Silk. French. 1969.

Lower right: Randomly tossed flowers in cool blues, greens, and lavender on purple. Fancy basketweave pattern. Cotton. French. 1966.

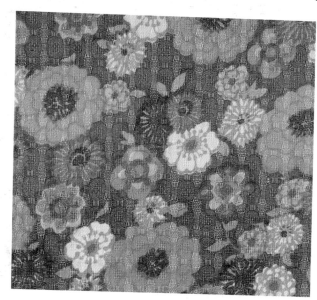

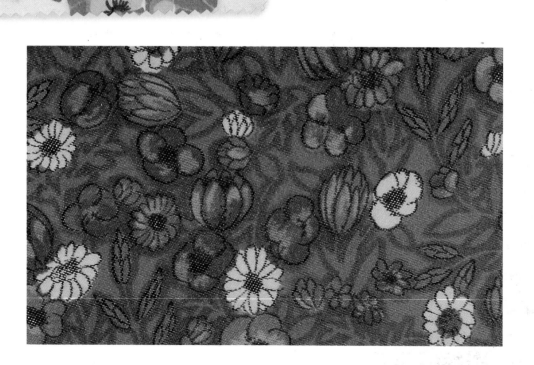

22

Top left: Primroses and other garden flowers in a bright print. Dark rose pink, hot orange, yellow, green, and black on white. Linen and silk. French. 1967.

Top right: Clusters of spring flowers are depicted in this design realistic enough to identify the flowers. Pink, purple, green, dark aqua, white, and brown on peach. Rayon and silk. French. 1967.

Lower: Allover tossed floral design. Pink, purple, white, chartreuse and medium green on cool blue ground. Brushed cotton. French. 1966.

Top left: Allover packed abstract floral clusters. Hot pink, purple, yellow, pale blue, and olive green. Silk. French. 1968.

Top right: Fields of flowers set in a patchwork-effect pattern. Fuchsia, yellow, orange, white, and green on bright pink. French. 1967.

Lower left: Interesting use of dots in a floral pattern. Fuchsia, blue, yellow, and green on pink. Heavy woven cotton. French. 1967.

Lower right: Mottled-look large florals in an allover packed design. Purples, pinks, orange, and olive green on black. Silk and rayon crepe. French. 1967.

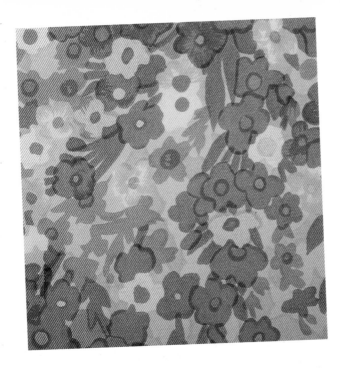

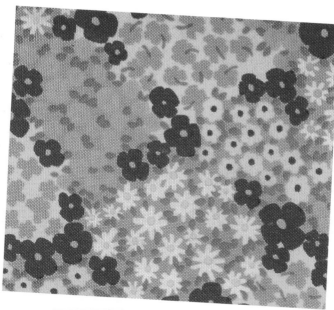

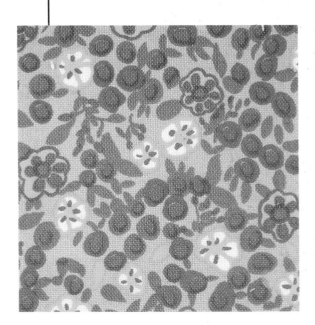

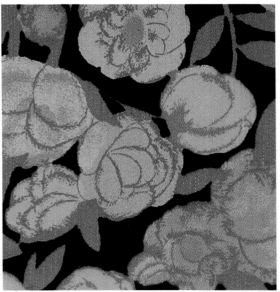

23

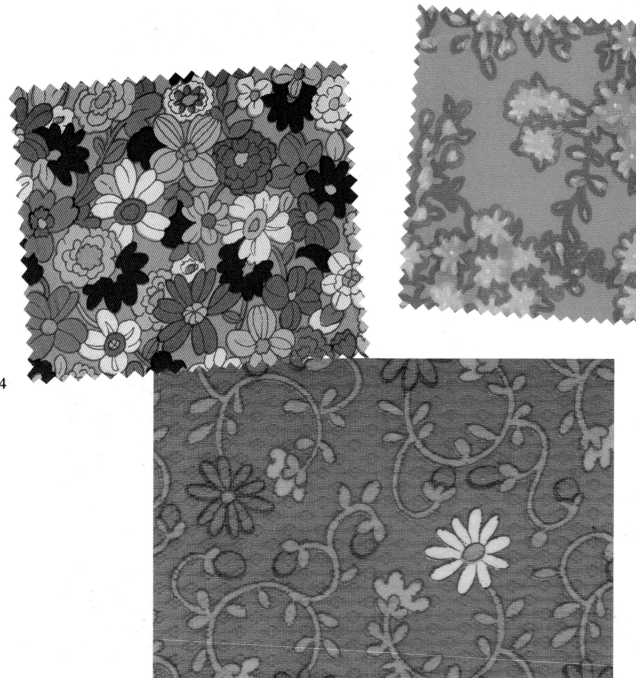

24

Top left: Packed flowers in pink, lilac, white, and green on aqua blue. Silk. French. 1968.

Top right: Tiny clusters of flowers with a slightly faded watercolor effect. Coral pink, yellow, purple, and green on bright aqua. Rayon. French. 1968.

Lower: Scrollwork patterned leaves lend graceful movement to this bright floral. Orange, deep aqua, white, and chartreuse on fuchsia. Textured honeycomb weave cotton. French. 1967.

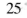

Above: Daisies in an abstract pattern. Pale pink, bright rose pink, periwinkle blue, and lime green on bright emerald green. Loose weave cotton and rayon. French. 1967.

Top right: Floral interpretation designed using coral-shape images. Hot pink, hot orange, green, and yellow on light blue. Silk. French. 1968.

Lower left: Tight flower pattern in an abstract style. Fuchsia, purple, and bright green on white. Open weave cotton and rayon. French. 1967.

Lower right: Stylized florals in a graceful swirling leaf pattern. Hot orange, fuchsia, kelly green, and dark brown on white. Cotton piqué. French. 1966.

25

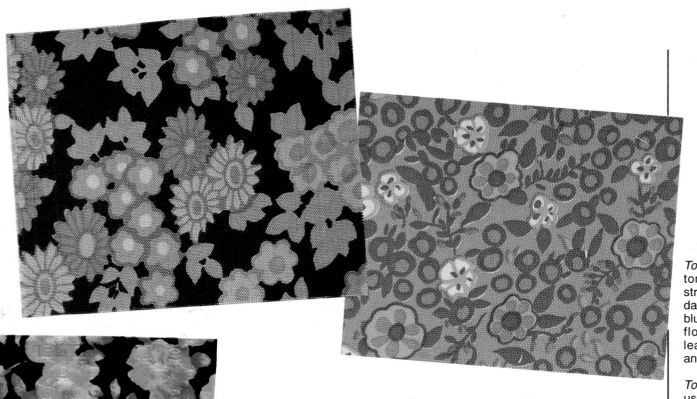

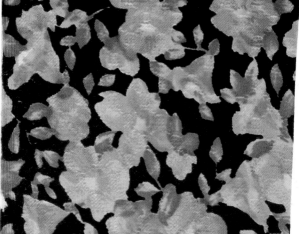

Top left: Cool and hot tones of color lend a striking contrast to the dark background. Pink, blue, green and purple florals, olive green leaves, on black. Silk and linen. French. 1967.

Top right: This design uses bright colors in a softer cool setting. The flowers are highly stylized with some depicted by dots. Bright pink, purple, orange-yellow, green and white on cool blue. Textured weave cotton. French. 1967.

Far left: Soft muted florals seem brighter on the dark background. Pinks, blues, greens, and yellow on black. Rayon and cotton knit in a textured weave. French. 1967.

Lower right: Bright cartoon-like flowers and leafy stems. Hot pink, fuchsia, blue, white, and green on black. Rayon acetate. French. 1969.

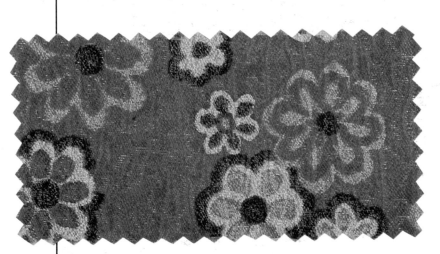

Top left: Splashy flowers on a textured serpentine weave fabric. Hot pink, chartreuse, and dark olive green on fuchsia. Silk and acrylic blend. French. 1968.

Top right: Floral clusters in a tightly packed design. Hot orange, hot pink, chartreuse, and periwinkle blue on dark purple. Textured honeycomb weave cotton. French. 1966.

Lower: Abstract florals and miniature leaves in a randomly tossed pattern. Hot pink, burgundy, yellow, taupe, and green on black. Rayon acetate. French. 1969.

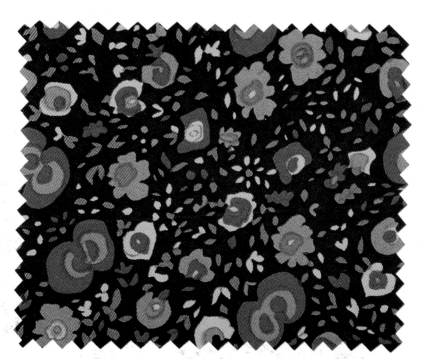

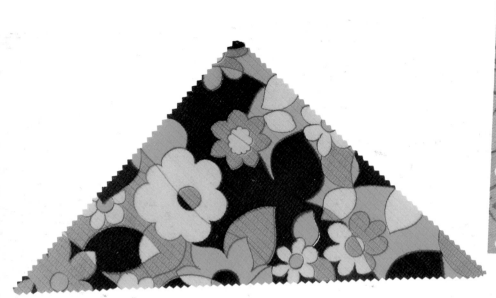

28

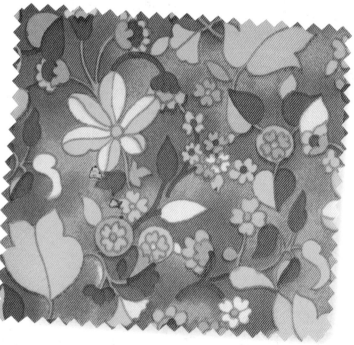

Top left: Large pattern hot floral print in ribbed cotton. Yellow, neon orange, khaki green on black. Italian. 1968.

Top right: Bright pink and orange florals in an all-over set, non-directional pattern. On aqua blue background. Silk. French. 1967.

Lower left: Tiny flowers set in an overall packed pattern. Pink, shocking pink, soft orange, white and green . Silk. French. 1967.

Lower right: Florals and vines on a faded mottled background. Bright yellow, lime green, pink, white, and emerald green on two-tone blue. Rayon and silk. French. 1968.

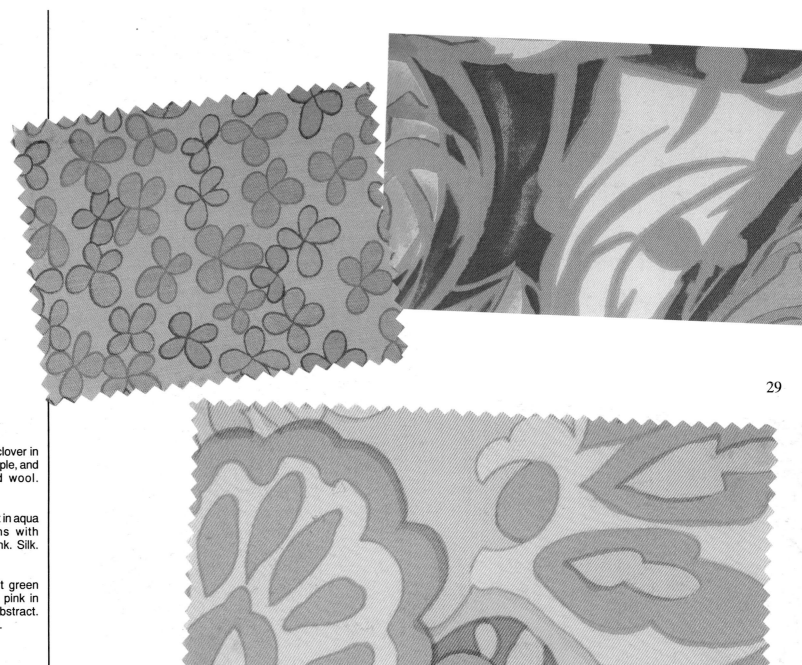

29

Top left: Field of clover in neon hot pink, purple, and green. Silk and wool. French. 1968.

Top right: Abstract in aqua and jade greens with dashes of hot pink. Silk. Italian. 1969.

Lower: Cool mint green contrast with hot pink in this floral-look abstract. Silk. Italian. 1969.

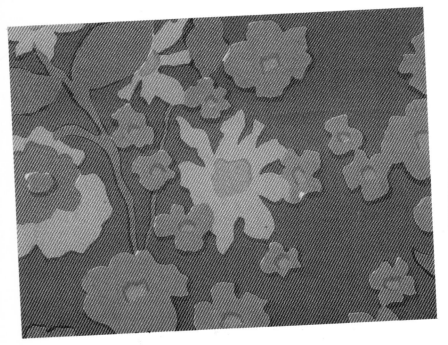

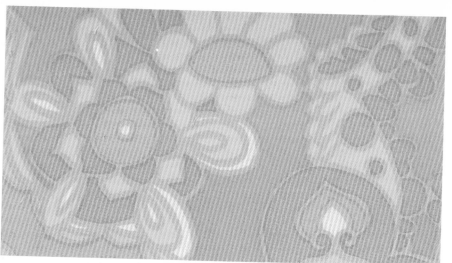

Top left: Abstract splotches of color in floral patterns. Hot orange, lilac, and brown on bright jade green. Silk. French. 1968.

Top right: Stylized flowers in hot orange, yellow, and mint green. Woven cotton twill. Italian. 1969.

Lower left: Allover packed design featuring stylized florals. Hot orange, mustard yellow, light and dark olive green on white. Embossed look diamond weave. Cotton. French. 1967.

Lower right: Flowers and buds with intertwining stems. Bright blues, white, and green on fuchsia. Polyester twill. French. 1968.

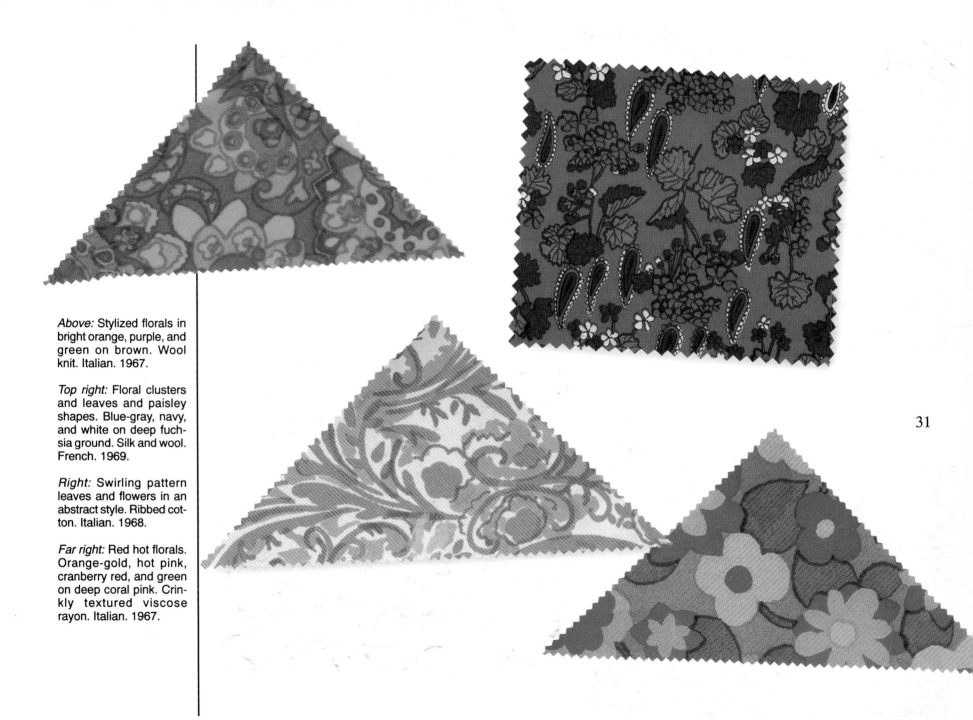

Above: Stylized florals in bright orange, purple, and green on brown. Wool knit. Italian. 1967.

Top right: Floral clusters and leaves and paisley shapes. Blue-gray, navy, and white on deep fuchsia ground. Silk and wool. French. 1969.

Right: Swirling pattern leaves and flowers in an abstract style. Ribbed cotton. Italian. 1968.

Far right: Red hot florals. Orange-gold, hot pink, cranberry red, and green on deep coral pink. Crinkly textured viscose rayon. Italian. 1967.

31

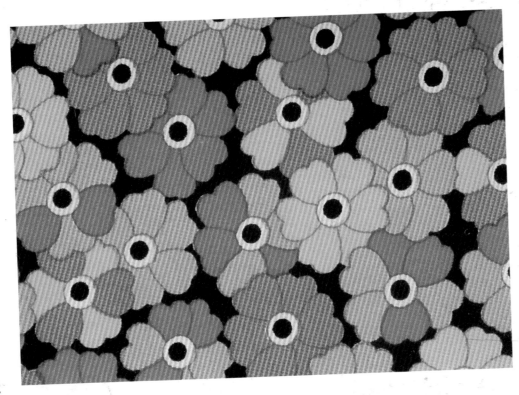

32

Top: Bold graphic medium sized flowers in a packed pattern. Golden yellow, orange, pink, taupe brown, and white on black. Textured rayon, nylon, and cotton blend. French. 1967.

Lower left: Stylized floral design in bright green and purple with graphic black outlines. Rayon. American. 1966.

Lower right: Flowers and leaves floating design. Orange, deep coral, cranberry red, chartreuse, olive green, and brown. Thin ribbed cotton. Italian. 1968.

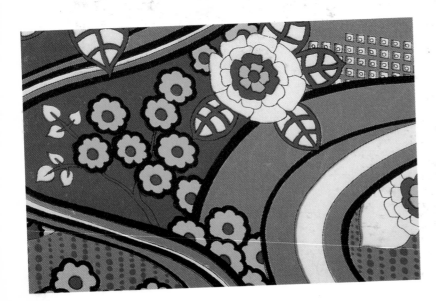

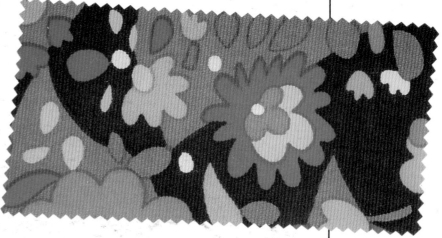

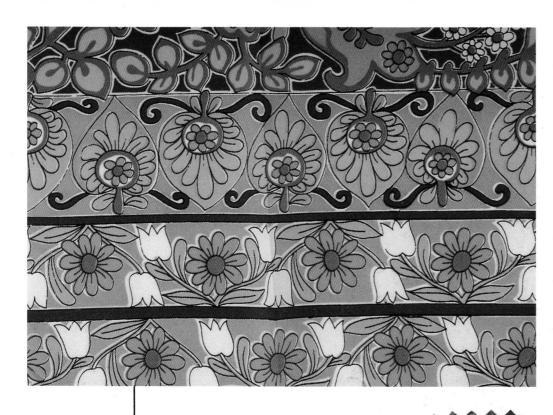

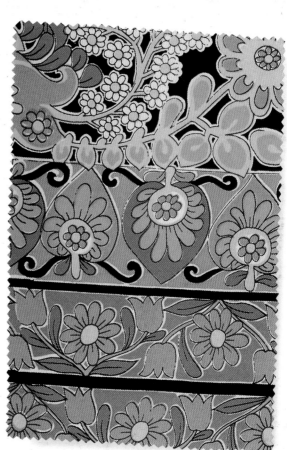

Above: Double border design in a floral stripe pattern. Orange, beige, white, and purple. Rayon. American. 1967.

Top right: Variation in orange, lilac, periwinkle blue, green, and deep aqua. Note the sharp contrast with black.

Right: Very abstract florals, striped stems and leaves. Citrus green, red, and medium brown on cadet blue. Polyester and rayon. French. 1969.

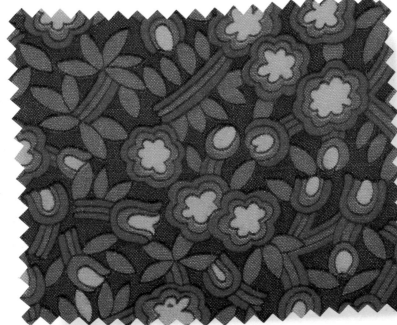

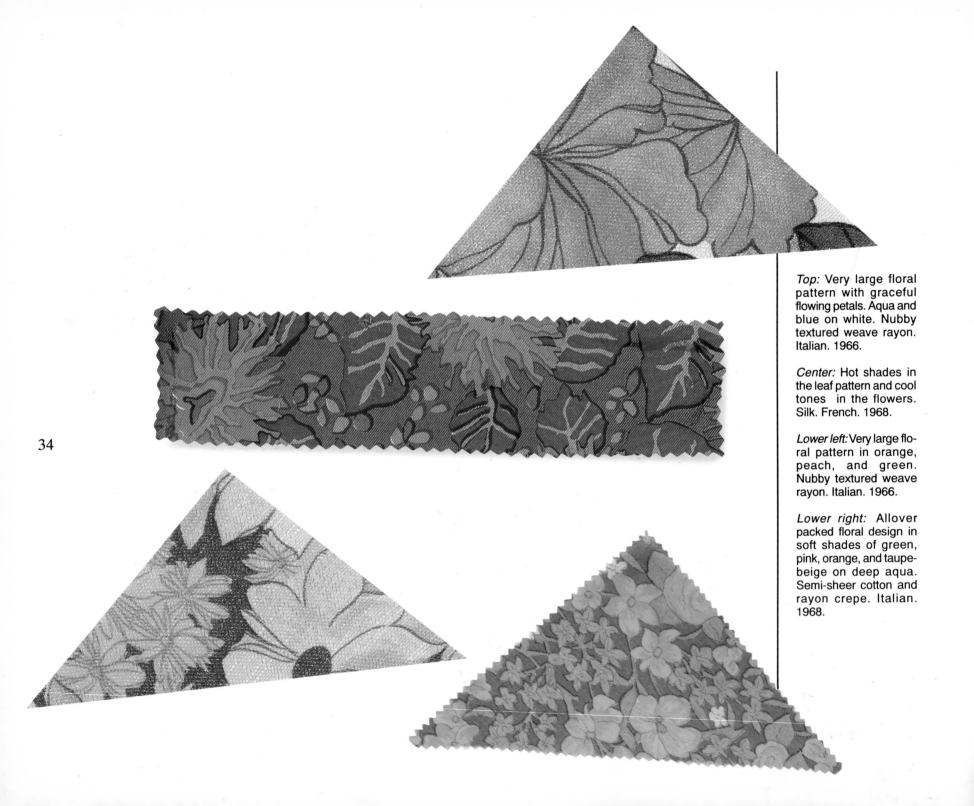

34

Top: Very large floral pattern with graceful flowing petals. Aqua and blue on white. Nubby textured weave rayon. Italian. 1966.

Center: Hot shades in the leaf pattern and cool tones in the flowers. Silk. French. 1968.

Lower left: Very large floral pattern in orange, peach, and green. Nubby textured weave rayon. Italian. 1966.

Lower right: Allover packed floral design in soft shades of green, pink, orange, and taupe-beige on deep aqua. Semi-sheer cotton and rayon crepe. Italian. 1968.

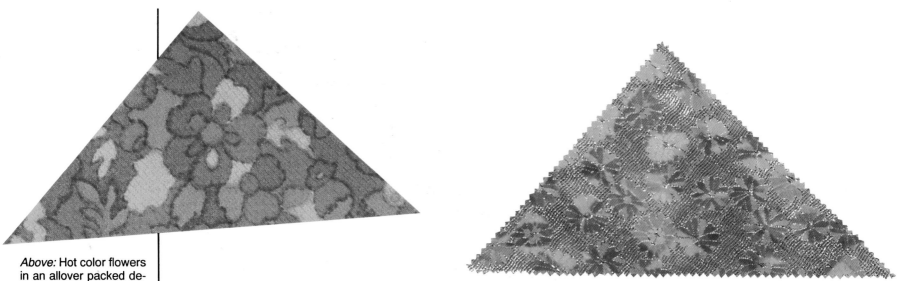

Above: Hot color flowers in an allover packed design. Golden yellow, hot pink, hot orange, light brown, and light olive green. Wool and rayon knit. Italian. 1967.

Top right: Embroidered flowers on shimmering metallic weave background. Hot pink, yellow, orange, and green. Cotton and silver lamé. Italian. 1967.

Lower left: Elegant floral design with a tiny, iridescent, allover leaf pattern background. Hot pink, golden yellow, periwinkle blue, light green, and jade green on gold. Silk and rayon. French. 1968.

Lower right: Flowers peeking out from between blades of grass. Hot pink, purple, yellow, taupe, and several tones of brown on dark brown. Wool knit. Italian. 1967.

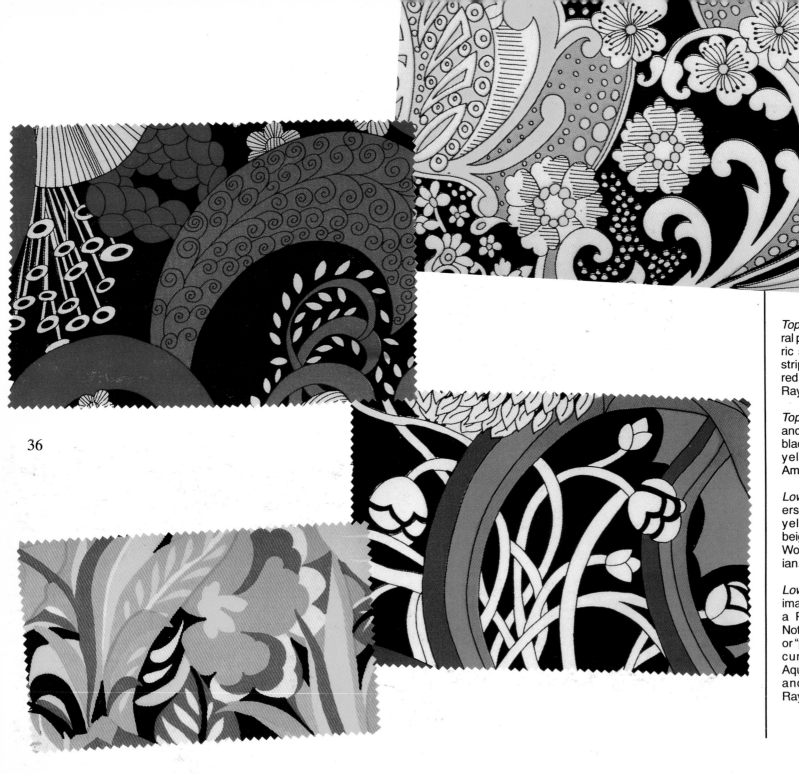

36

Top left: Very stylized floral pattern using geometric shapes, circles, and stripes. Shocking pink, red, and white on navy. Rayon. American. 1966.

Top right: French curves and flowers in a graphic black, white, and bright yellow print. Cotton. American. 1967.

Lower left: Graphic flowers and leaves. Bright yellow, orange, red, beige, white, and black. Woven cotton twill. Italian. 1969.

Lower right: Whimsical images with the look of a Peter Max design. Note the use of picotage, or "pinning" in the French curves and circles. Aqua, red, yellow, pink, and blue on white. Rayon. American. 1967.

PAISLEY

Top: Psychedelic paisley print. Hot pink, hot orange, yellow, kelly green and olive green. Rayon jersey knit. French. 1968.

Lower left: Large paisley shapes are spaced between tiny scroll-look vines with flowers. Shocking pink, purple, and olive floral paisley on medium blue. Silk. French. 1967.

Lower right: Paisley border print in hot pink, purple, and white. Rayon. American. 1967.

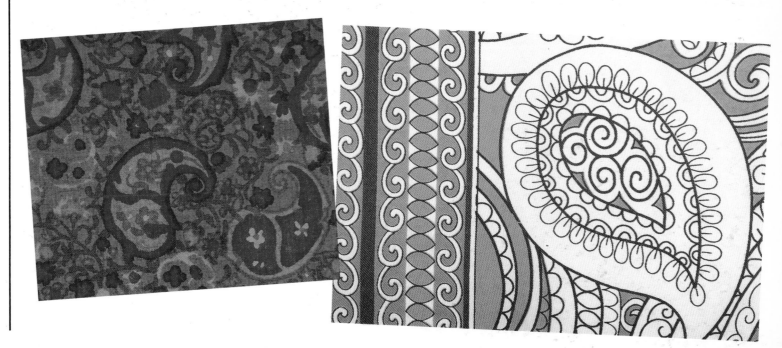

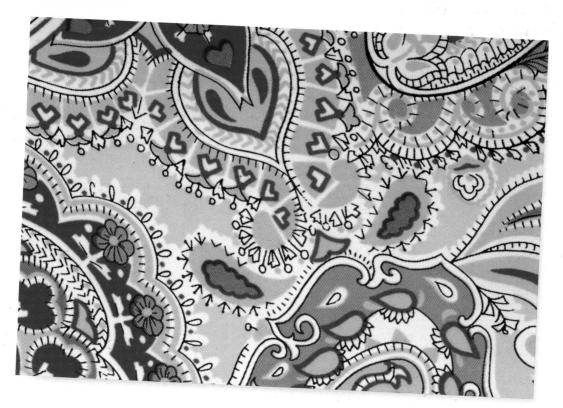

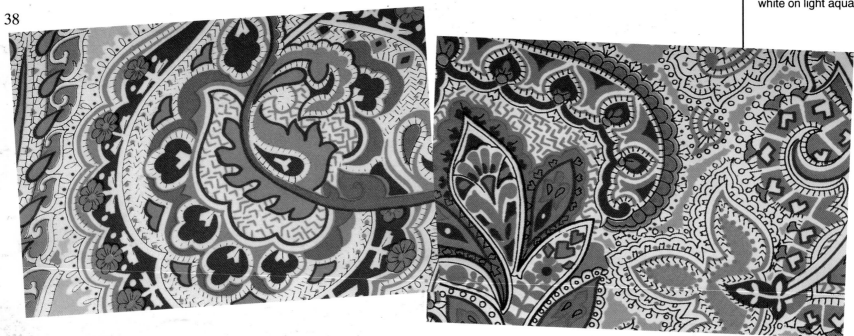

Top: Bandanna paisley print. Hot orange, gold, red, and white on yellow. Rayon. American. 1967.

Lower left: Variation in hot pink, bright green, and blue on pink.

Lower right: Variation in lavender, purple, bright green, deep aqua, and white on light aqua.

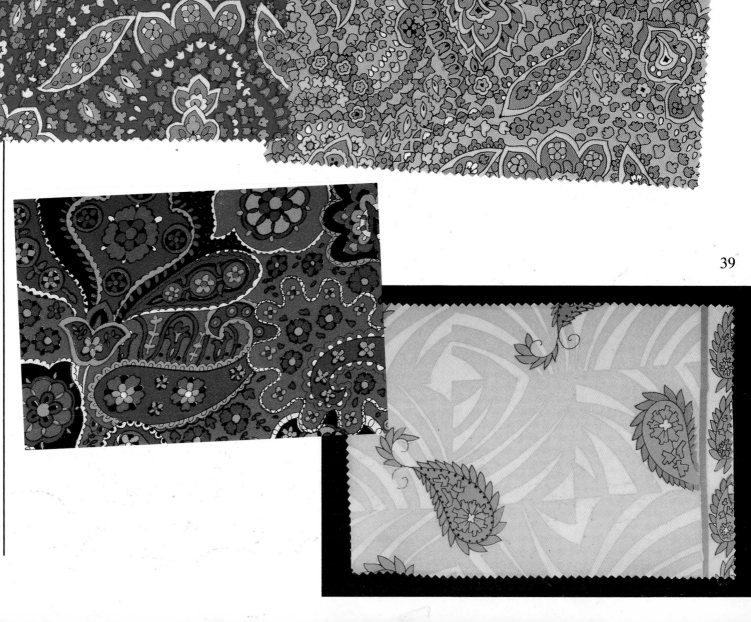

Above: Hot paisley pattern. Orange, beige, green, and white on red. Rayon. American. 1966.

Top left: Variation in yellow, orange, lilac, and green on aqua, white, and black on blue. Rayon. American. 1966.

Lower left: A bolder variation orange, bright blue, white, and black on red.

Lower right: Op art block pattern with paisley shapes and a paisley border. Bright yellow, orange, copper-gold, and green on white. Silk. American. 1966.

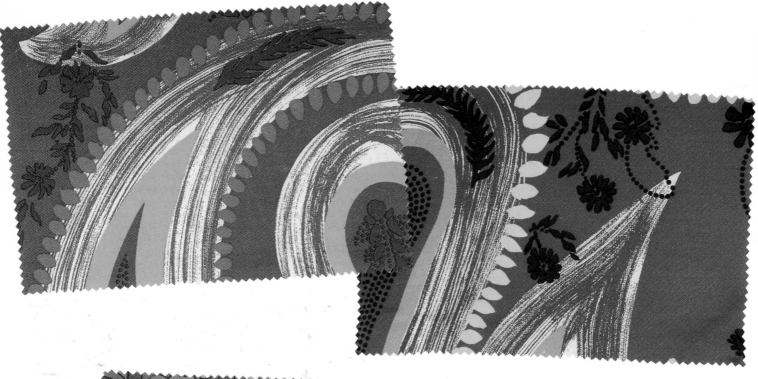

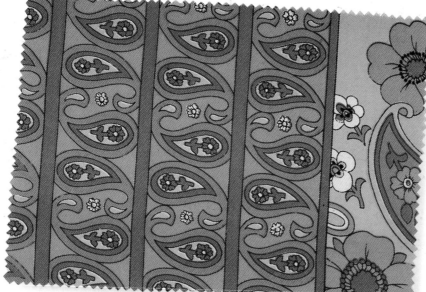

Top left: Large pattern paisley with creative use of dry-brushing. Green, turquoise, purple, and white. Rayon. American. 1966.

Top right: Variation in yellow, orange, blue, and red.

Lower left: Paisley border design on a paisley floral pattern. Rayon. American. 1969.

Below: A color variation of the same fabric design shown without the paisley border. Gold, orange, lavender, purple, and white on beige.

GEOMETRIC

DOTS & CIRCLES

Above: Polka dots arranged in a tentacle fashion. Hot pink, neon green, orange-red, aqua, white on navy blue. Silk. Italian. 1968.

Lower left: Lots of dots in a allover packed design. Hot pink, bright purple, golden yellow, and black on dark teal green. Rayon. French. 1968.

Lower right: Confetti polka dots set in a stripe pattern. Bright green and navy on fuchsia. Silk crepe de chine. French. 1968.

42

Top left: Polka dot design. The darker dots are use to create a pattern, in this case a design in the shape of buildings. Neon yellow and peacock blue on white. Silk. American. 1968.

Top right: Variation in hot pink and bright green.

Center right: Variation in yellow and orange.

Lower: Classic polka dot in a set pattern. White on hot pink. Silk. American. 1968.

Top right: Polka dot design set in geometric boxed pattern. Green and purple on white. Rayon. American. 1968.

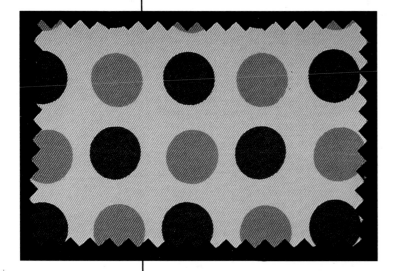

43

Above and right: Three variations of the classic polka dot pattern with alternating colors. Shown in peacock blue and black, hot pink and black, and bright orange and black. Silk. French. 1968.

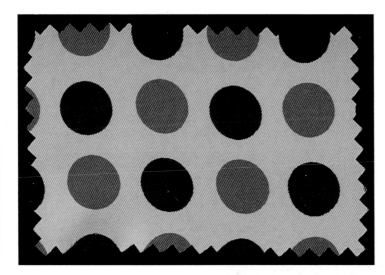

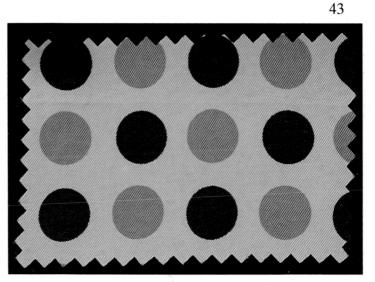

LIVERPOOL JOHN MOORES UNIVERSITY

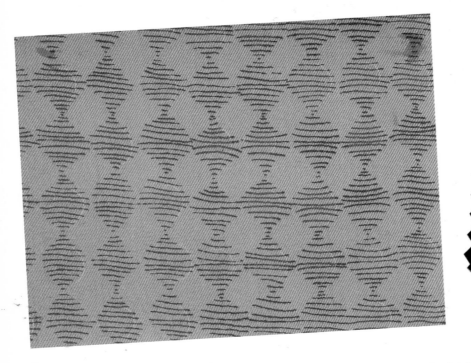

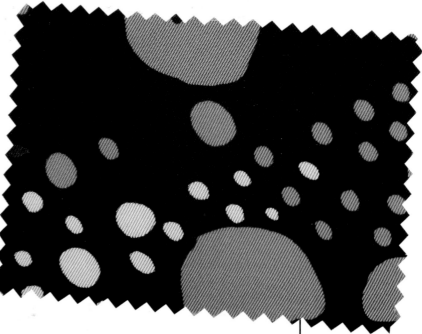

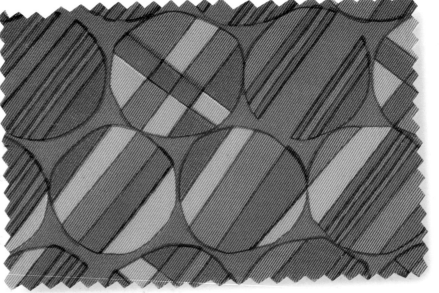

Top left: Modified diamond checks and polka dot pattern. Note that the shapes are formed by miniature pin stripes. Gold dots, dark brown stripes on aqua. Silk. French. 1968.

Top right: Small stylized floral print in neon green, hot pink, and electric blue on black. Crinkly cotton. Italian. 1966.

Lower: Stripes and plaids inside large circles in a set pattern. Tangerine, purple, blue, and green on hot orange. Acetate taffeta. French. 1968.

Top: Circle pattern with a stained glass look. Pink, yellow, chartreuse, gold, and white on sand. Rayon. American. 1967.

Lower left: Variation in aqua, periwinkle, lilac, and white on beige.

Lower right: Variation in rosebud pink, hot pink, orange, lilac, peach, and white on beige.

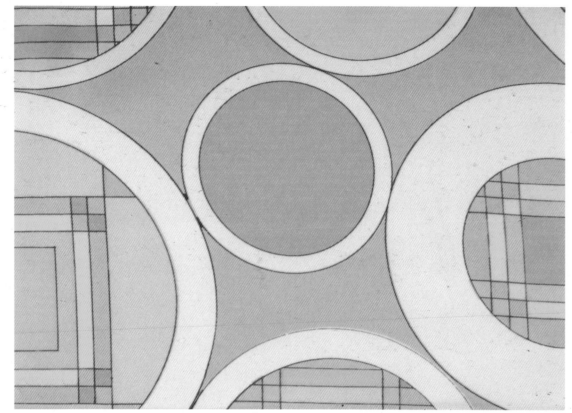

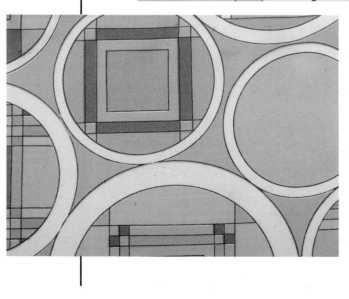

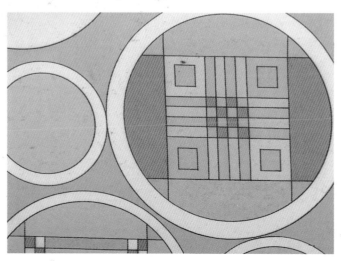

45

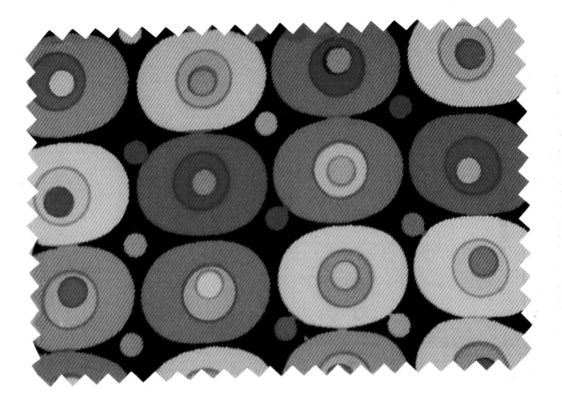

Top: Eyeball-effect design featuring dots, circles, and ovals in a set pattern. Hot pink, hot orange, gold, yellow, red, and aqua blue on black. Silk. French. 1968.

Lower left: Big circles with graduated shades of color and stripe or check design. Yellow, gold, orange sherbet, and hot orange, aqua, and emerald green on white. Rayon. American. 1969.

Lower right: Large circle patterns formed by paisley shapes. Orange, fuchsia, burgundy, and brown on white. Rayon cotton knit. French. 1968.

46

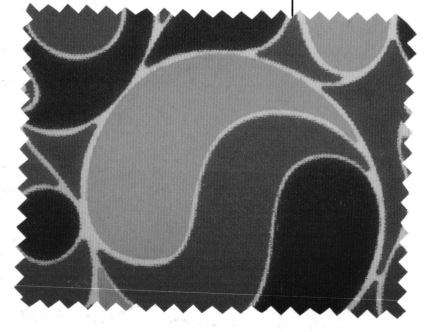

Top: Hot pink and white squares in different sizes float on dark navy blue. Silk. French. 1968.

Lower left: Tiny squares in an allover packed layout. Hot orange, brown, and white, on navy blue. Silk. American. 1967.

Lower right: Tiny flowers and triangles form an orderly diamond check pattern. Silk. French. 1968.

GEOMETRIC
CHECKS & BOXES

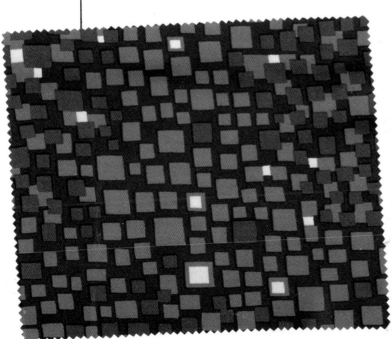

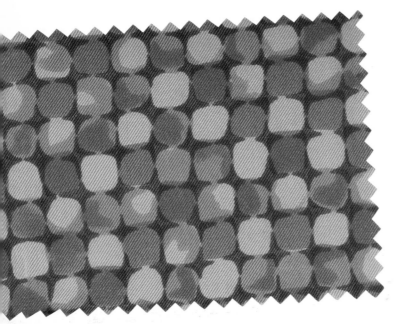

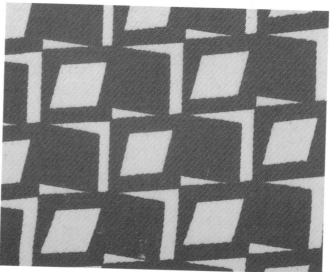

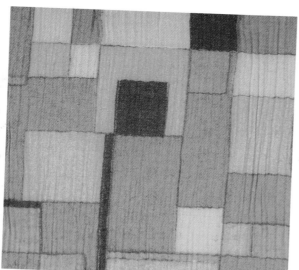

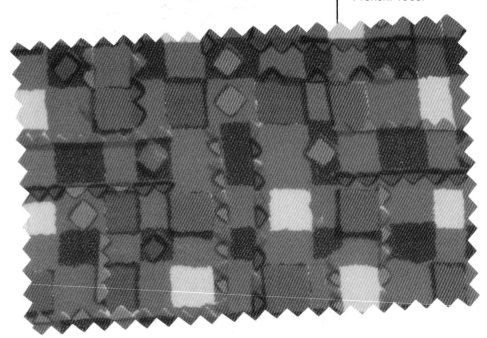

Top left: Watercolor effect shaded boxes with rounded corners in a check pattern. Tangerine, and two tones of orange on charcoal gray. Silk. French. 1968.

Top right: Very graphic rendering of a novelty check pattern. Hot rose pink and white. Silk and rayon. French. 1968.

Lower left: Mosaic tile pattern in yellow, tangerine, light brown, purple, and bright green. Crinkly rayon and cotton. French. 1967.

Lower right: Geometric squares, rectangles, and triangles in an unspecified pattern. Emerald green, blue, purple, and white on hot pink. Silk. French. 1968.

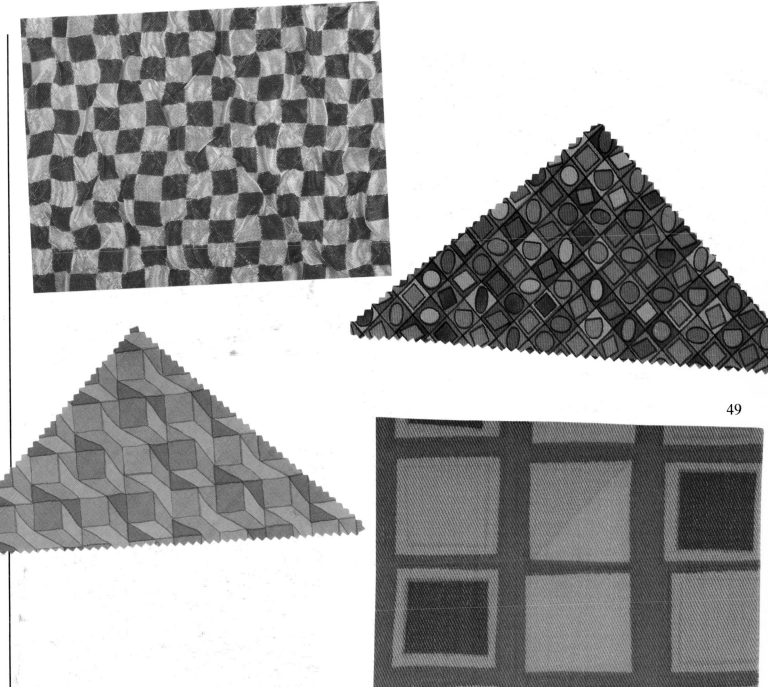

Top left: The basic check pattern updated with color and fabric treatment. The puckered look is achieved by the stitching that forms a diamond check. Hot pink and white. Silk, polyester, and nylon with tricot lining. French. 1969.

Top right: Geometric patterns set in a box check. Gold, hot orange, and brown. Polished cotton. Italian. 1968.

Below: The illusion of a three-dimensional pattern in three tones of green, chartreuse, gold and lavender. Cotton and rayon. Italian. 1968.

Lower right: Colorful blocks set in a checked pattern. Hot orange, hot pink, purple, and olive green on bright medium green. Cotton and rayon twill. French. 1966.

49

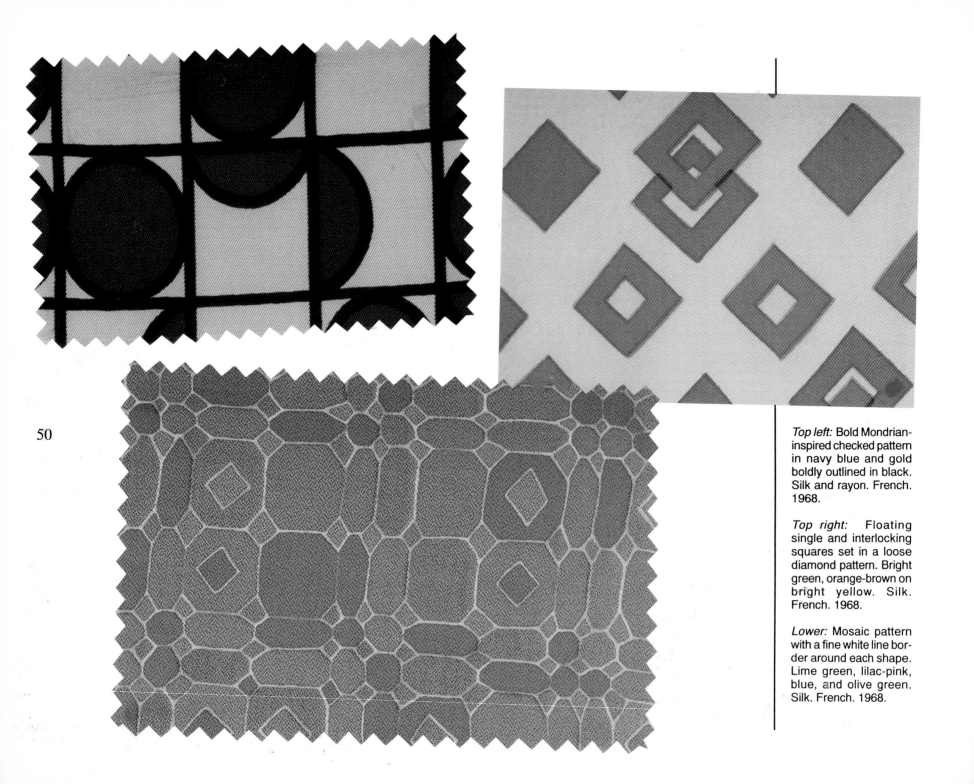

50

Top left: Bold Mondrian-inspired checked pattern in navy blue and gold boldly outlined in black. Silk and rayon. French. 1968.

Top right: Floating single and interlocking squares set in a loose diamond pattern. Bright green, orange-brown on bright yellow. Silk. French. 1968.

Lower: Mosaic pattern with a fine white line border around each shape. Lime green, lilac-pink, blue, and olive green. Silk. French. 1968.

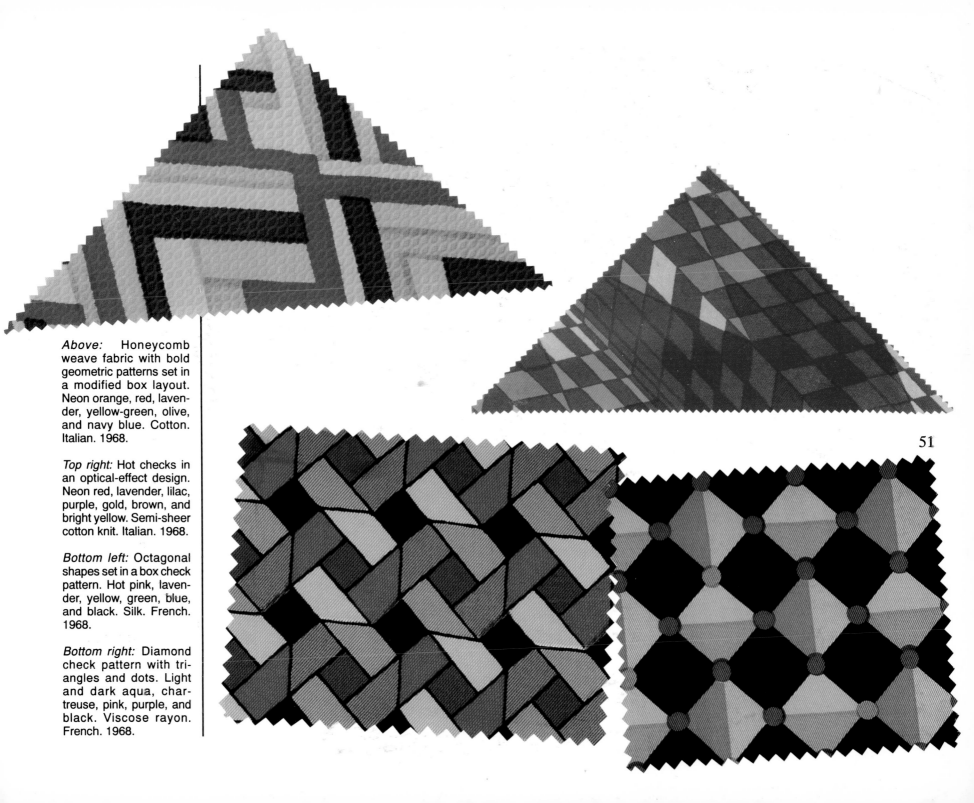

Above: Honeycomb weave fabric with bold geometric patterns set in a modified box layout. Neon orange, red, lavender, yellow-green, olive, and navy blue. Cotton. Italian. 1968.

Top right: Hot checks in an optical-effect design. Neon red, lavender, lilac, purple, gold, brown, and bright yellow. Semi-sheer cotton knit. Italian. 1968.

Bottom left: Octagonal shapes set in a box check pattern. Hot pink, lavender, yellow, green, blue, and black. Silk. French. 1968.

Bottom right: Diamond check pattern with triangles and dots. Light and dark aqua, chartreuse, pink, purple, and black. Viscose rayon. French. 1968.

51

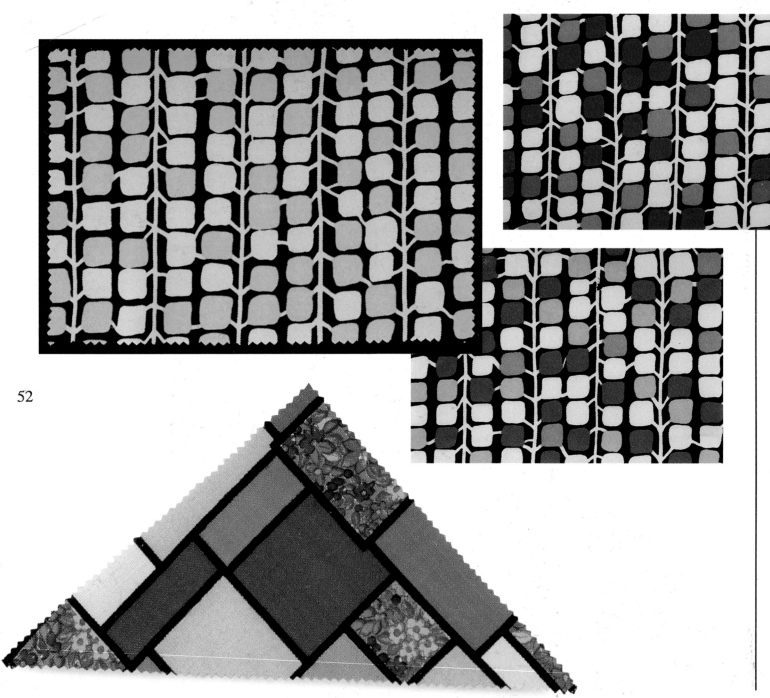

52

Top left: Stylized branches and leaves in a horizontal stripe pattern. White and yellow on black. Silk. American. 1966.

Top right: Variation in pink, red, and purple.

Left: Variation in green, orange, and brown.

Lower left: Mondrian-look design with patches of small floral patterns. Bright yellow, white, blue, aqua, and green outlined in black. Multicolor florals on pink background. Textured woven viscose rayon. Italian. 1968.

Above: Marshmallow shapes stacked in a double row stripe pattern. Aqua, gold, red, and purple. Silk. American. 1968.

Top right: Variation in greens, blue, and bright orange.

Center: Variation in shocking pink, bright orange, yellow, and purple.

Lower: Diamonds, squares, and rectangles in a mosaic pattern. Bright golden yellow, tangerine, orange-red, bright red, and lilac. Semi-sheer cotton. Italian. 1968.

53

54

Top left: Zig-zag stripes in a box check pattern. Orange-yellow, deep coral, lavender, and olive green. Silk. Italian. 1968.

Top right: Variation of a harlequin pattern with beaded chain-look stripes. Chartreuse, green, gray, and black. Silk. Italian. 1968.

Bottom left: Various undefined shapes in a modified box check pattern. Deep lilac on three shades of bright green. Silk. French. 1968.

Below: Concentric squares in a box layout over an abstract background. Purple, orange, golden yellow, and light gray on white. Silk and rayon. American. 1968.

Top left: Dashes of white lend a textured look to this patchwork design. Pink, purple, beige, and sand. Silk. American. 1967.

Top right: Variation in sand, yellow, orange, and gray.

Center: Concentric boxes in a set pattern. Mint green, fuchsia, orange, and black on white. Arnel jersey knit. French. 1969.

Lower right: Very large plaid pattern in pink, purple, deep mint green, and yellow. Polished cotton. Italian. 1966.

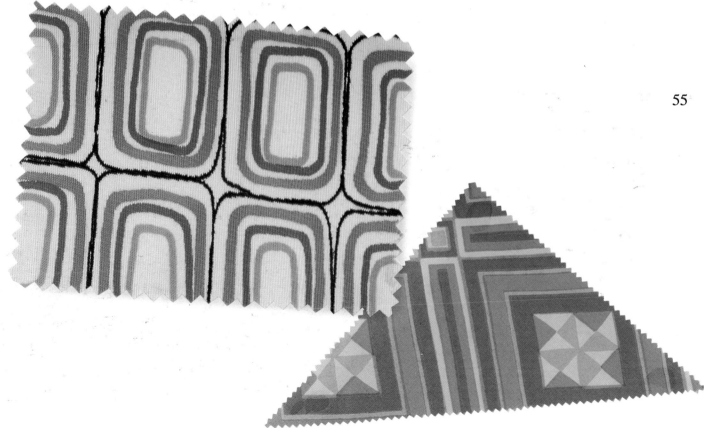

55

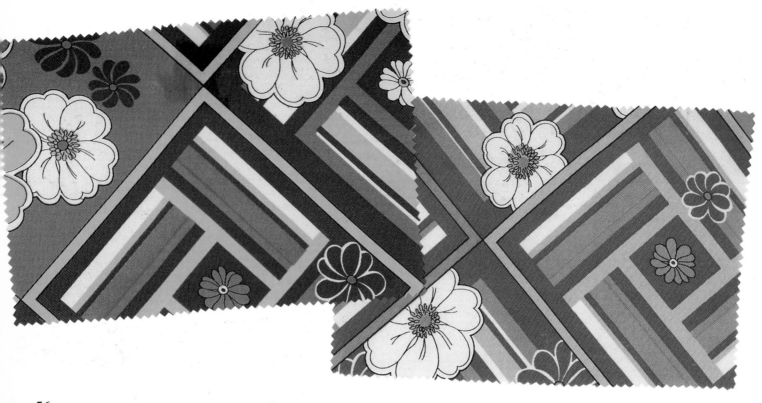

56

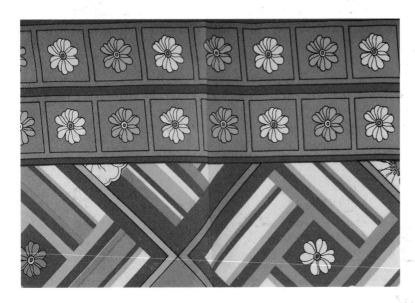

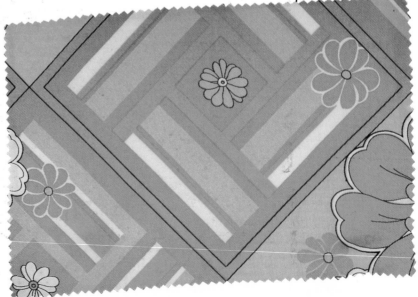

Top left: Floral and modified plaid pattern in an Oriental-look border design. The border portion of the design is not shown. Rayon. American. 1969.

Top right: Variation of the design in hot pink, orange, yellow, and white.

Lower left: The same pattern shown with the boxed floral border.

Lower right: Variation in yellow, gold, and orange.

Top left: Cross-hatch designs in a modified patchwork. Turquoise and royal blue on white. American. 1969.

Top right: A variation of the design in chartreuse, bright green, and black on white.

Lower left: Large scale design that resembles spots on a giraffe. Hot orange, golden yellow, purple, deep peacock blue, gray, and brown. Silk. Italian. 1969.

Lower right: Photograph of the overall pattern reveals an alligator skin-effect diamond check in a patchwork design.

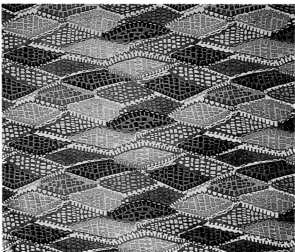

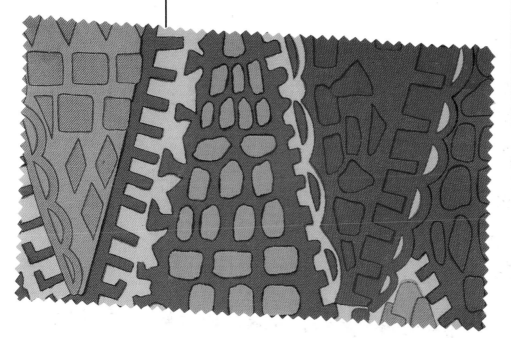

57

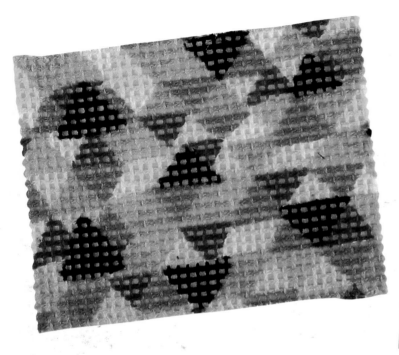

Top left: Multi-tones triangles in a semi-set pattern. Bright yellow, bright orange, olive green, gray, and black. Heavy open-weave cotton and linen. French. 1966.

Top right: Diagonal box plaid with large and small squares. Bright yellow and black on white. Rayon. American. 1968.

Lower left: Geometric shapes in a packed design. Pink, yellow, dark peach, and browns on white. Novelty twill weave cotton. Italian. 1968.

Lower right: Simple diamond check pattern. Interestingly, the tiny green dots are placed in a random fashion. Yellow, and green on purple. Pinwale cotton corduroy. Italian. 1967.

58

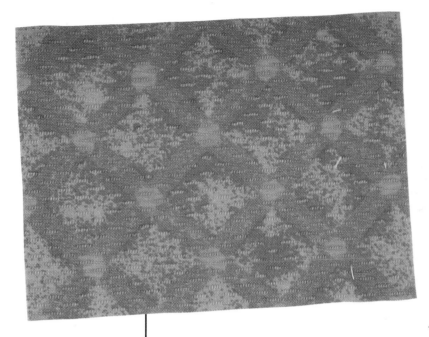

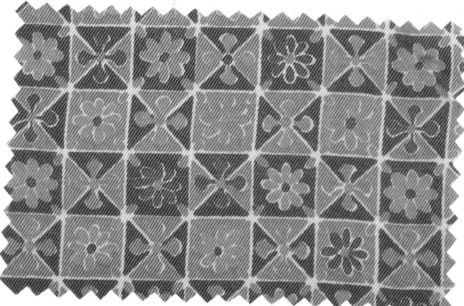

Above: Diagonal plaid on mottled background. Pinks and greens. Textured horizontal weave rayon and silk. French. 1967.

Top right: Interesting floral checked pattern overlaid with a second diagonal diamond check. Blue and purple checks with white outline, hot pink, bronze gold and green florals. Silk. French. 1968.

Lower: Novelty check using hot pink flowers, green leaves, and black boxes. Silk. French. 1968.

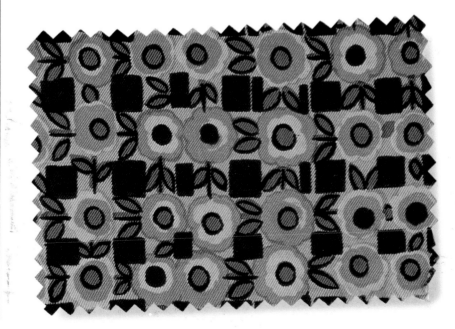

59

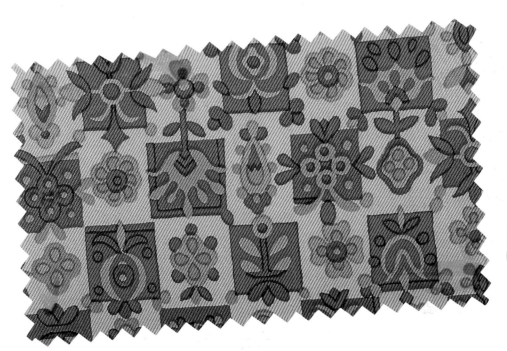

60

Top left: Novelty design in a check pattern. Turquoise, golden yellow, brown, hot pink, and aqua. Rayon and silk. French. 1968.

Top right: Large and small stylized flowers set in a geometric set alternating large and small block pattern. Hot pink, hot orange, beige and medium brown. Heavy nubby textured cotton and linen blend. French. 1966.

Lower left: Modified diagonal check pattern with scattered tiny flowers. Neon orange, yellow-gold, white, turquoise and green. Ribbed cotton. Italian. 1968.

Lower right: Floral repeat pattern, allover set design. Golden yellow, hot pink, and mint green on medium green ground. Woven cotton and rayon blend. French. 1966.

Top left: A single stem flower framed by a modified diamond shape is repeated in this set pattern. Shocking pink, medium pink, and green on bright orange-yellow. Crinkly rayon. French. 1966.

Top right: Diamond shape and zig-zag stripes, Olive and orange on fuchsia. Silk shantung. French. 1967.

Lower left: Leaves and dots form a set diamond pattern, each centered by a single flower. Bright pink and white flowers, pink and white dots, olive green leaves on turquoise. Polyester and rayon crepe. French. 1967.

Lower right: Variation of a diamond shape pattern with an interesting ribbon-like border. Bright green, and light blue on bright yellow. Silk crepe de chine. French. 1968.

Top: Mosaic layout of geometric shapes. The fascinating novelty weave features a checked pattern with alternating puckered and tiny woven checks. Pink, green, beige and brown. Worsted wool, acetate, rayon, and acrylic blend. French. 1968.

Lower left: Large novelty print featuring florals set in a random geometric pattern. Bright blue, red, purple, white and green. Semi-sheer ribbed stretch polyester and cotton. Italian. 1968.

Below: Impressionistic interpretation of a diamond check pattern. Yellow, tangerine, bright green, and forest green. Silk shantung. French. 1968.

62

Top: Multicolor boxes in an overall plaid design. Bright blue, bright pink, aqua, and beige on two-tone brown mottled background. Polyester crepe. French. 1969.

Lower left: Shapeless strips intersect in an abstract plaid pattern. Silk shantung. French. 1968.

Lower right: Eye-popping stylized plaid. Hot pink, hot orange, and purple on bright blue. Silk executed in a fine twill weave. French. 1968.

GEOMETRIC
PLAID

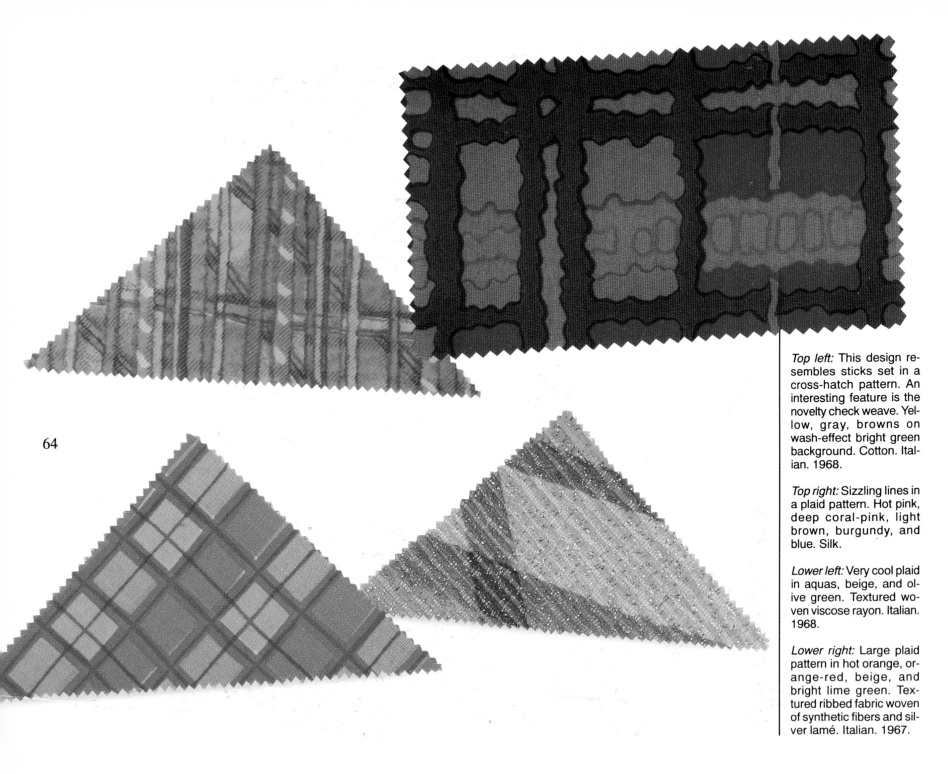

64

Top left: This design resembles sticks set in a cross-hatch pattern. An interesting feature is the novelty check weave. Yellow, gray, browns on wash-effect bright green background. Cotton. Italian. 1968.

Top right: Sizzling lines in a plaid pattern. Hot pink, deep coral-pink, light brown, burgundy, and blue. Silk.

Lower left: Very cool plaid in aquas, beige, and olive green. Textured woven viscose rayon. Italian. 1968.

Lower right: Large plaid pattern in hot orange, orange-red, beige, and bright lime green. Textured ribbed fabric woven of synthetic fibers and silver lamé. Italian. 1967.

Top: Eye-catching plaid in hot pink, chartreuse, and white. Silk crepe de chine. American. 1968.

Lower left: Variation in aqua and lilac.

Lower center: Variation in yellow and orange.

lower right: Variation in green and deep purple.

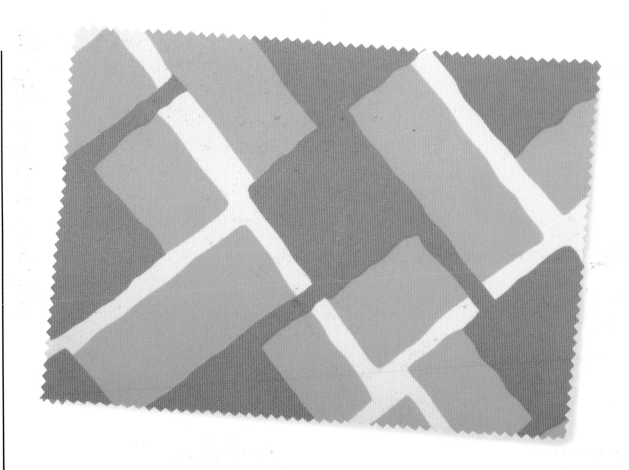

65

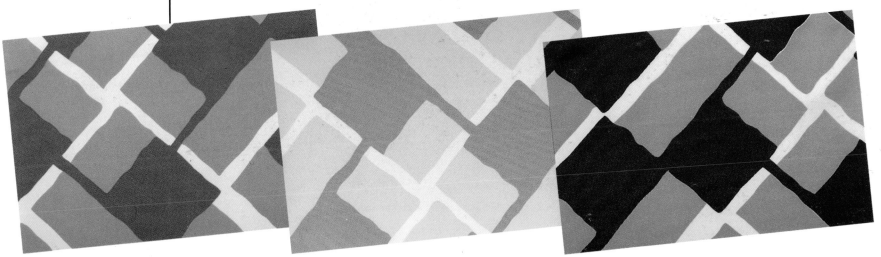

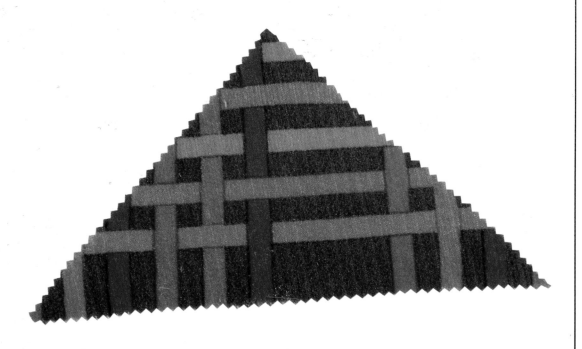

Top: Colorful bands in a woven design creating a large plaid pattern. Lime green, hot pink, lavender, purple, light brown, and olive green on dark green. Wool. Italian. 1967.

Lower left: Cross hatching lines in varied patterns give this design a patchwork effect. Turquoise and blue on white. Cotton and rayon. American. 1968.

Lower right: Variation of the same design in hot pink, chartreuse, neon green, and purple on white.

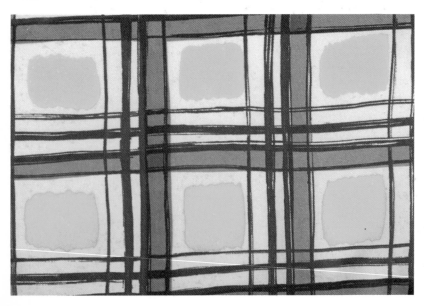

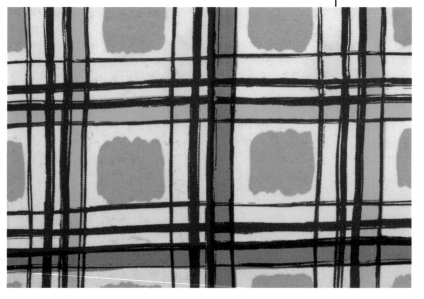

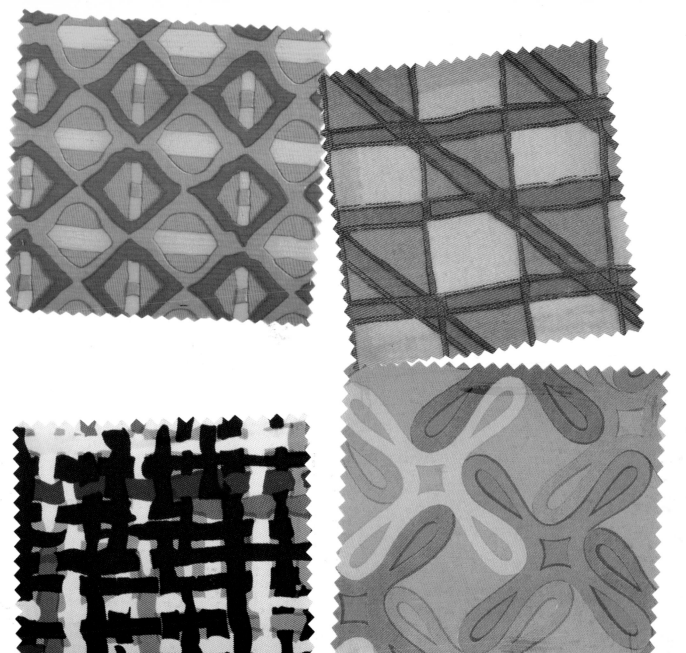

Top left: Interesting plaid pattern combining a box check overlaid with a diagonal diamond check. Bright green, blue, and yellow on pink. Polyester crepe. French. 1967.

Top right: Watercolor effect novelty plaid with the look of stained glass. Aqua, lilac, blue, and dark gray. Silk and rayon. French. 1968.

Lower left: Woven look print in white, navy, purple, pink, gold, and green on gray. Silk. French. 1968.

Lower right: Looped crosses interlock to create a diagonal check pattern. Aqua, yellow, olive green, taupe, and periwinkle on hot pink. Silk. French. 1968.

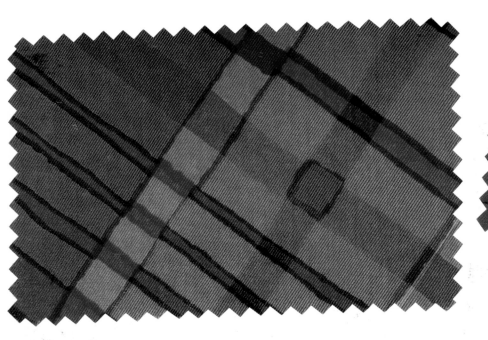

68

Top left: Madras-look plaid with a watercolor wash effect. Hot pink, green, purple and olive green. Silk. French. 1968.

Top right: Bold plaid in aqua, sapphire blue, golden yellow, red, deep fuchsia, and black. Rayon acetate twill. French. 1968.

Lower left: This fabric has a faux woven look with scroll-effect designs. Fuchsia, purple, and burgundy. Silk and wool. French. 1968.

Lower right: Geometric shapes in a modified plaid design. Hot orange, rose pink, lilac, golden yellow, light olive green, and gray. Arnel acetate. French. 1968.

Above: Colorful shapes in a modified stripe pattern. Deep aqua, turquoise, peacock blue, lavender, cadet blue, copper brown on white. Ribbed woven cotton. Italian. 1968.

Lower left: Nubby-textured rainbow stripe pattern. Pink, purple, navy, turquoise, yellow, orange, and lime green. Rayon and silk. French. 1967.

Lower right: Modified striped pattern in hot pink, lilac, citrus yellow, and aqua. Silk. French. 1968.

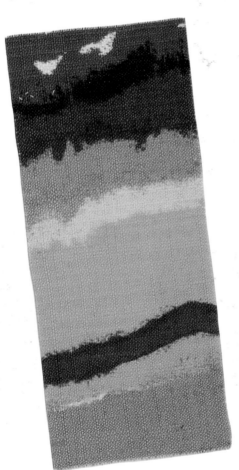

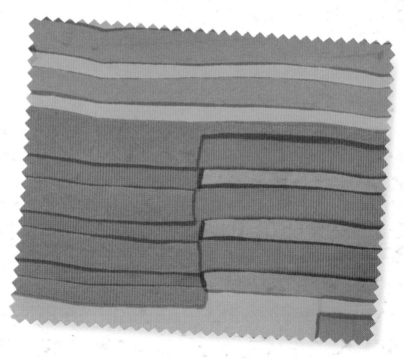

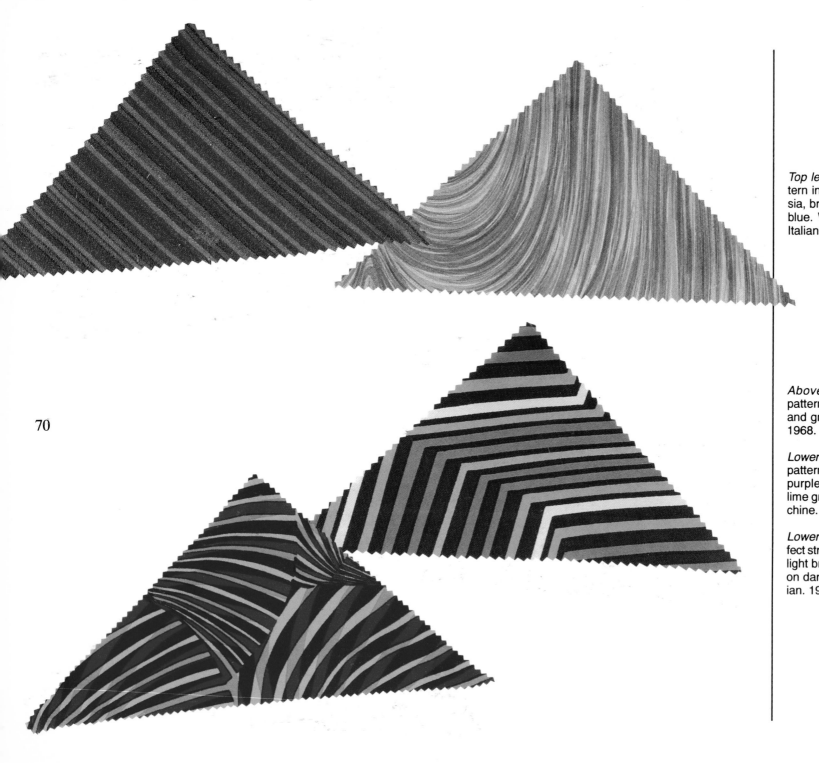

70

Top left: Thin stripe pattern in hot orange, fuchsia, brown, and peacock blue. Woven rayon knit. Italian. 1968.

Above: Swirling stripe pattern in pinks, purples, and greens. Silk. Italian. 1968.

Lower left: Optical-effect pattern in shocking pink, purple, chartreuse, and lime green. Silk crepe de chine. Italian. 1968.

Lower right: Optical-effect stripes. Beige, taupe, light brown, and hot pink on dark brown. Silk. Italian. 1968.

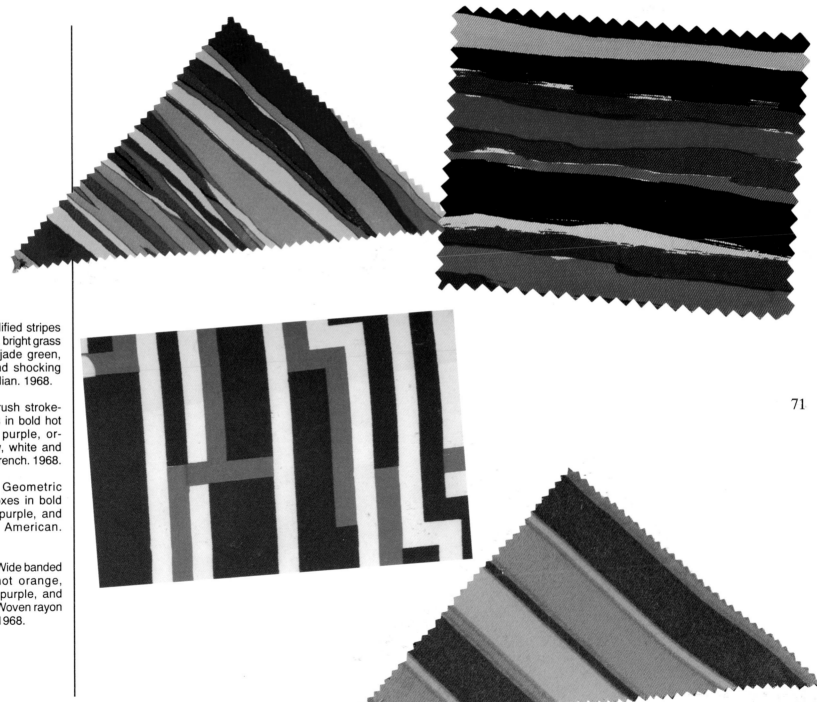

Top left: Modified stripes in chartreuse, bright grass green, dark jade green, burgundy and shocking pink. Silk. Italian. 1968.

Top right: Brush stroke-effect stripes in bold hot pink, aqua, purple, orange, yellow, white and black. Silk. French. 1968.

Lower left: Geometric bars and boxes in bold teal green, purple, and white. Silk. American. 1968.

Lower right: Wide banded stripes in hot orange, chartreuse, purple, and olive green. Woven rayon knit. Italian. 1968.

71

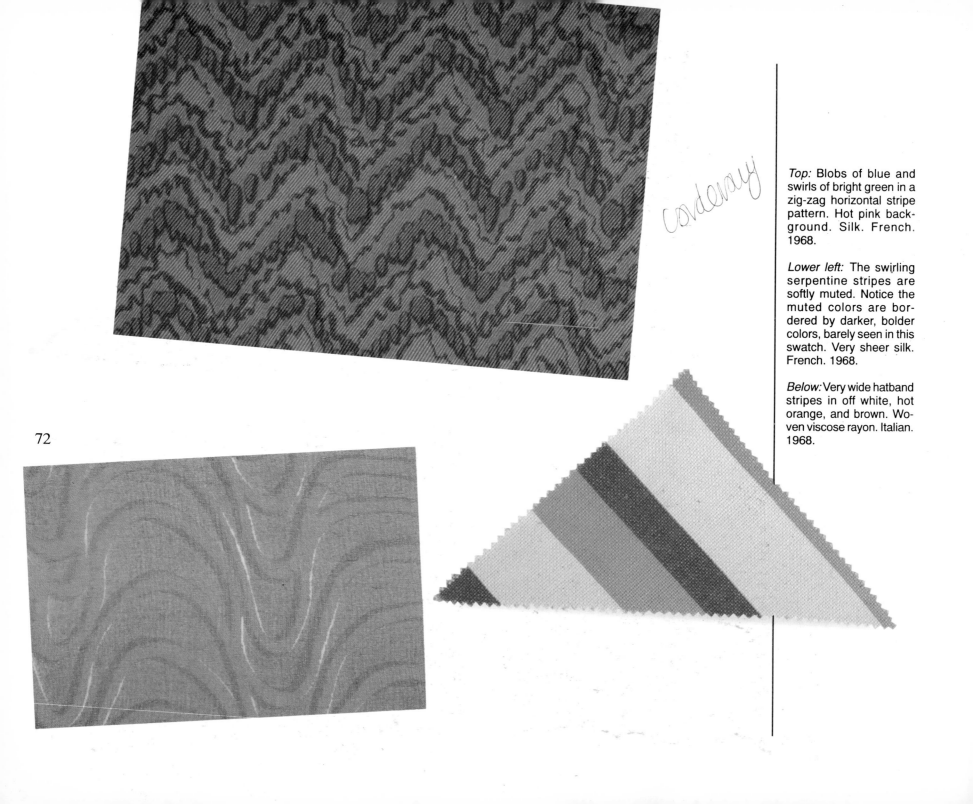

Corderoy

72

Top: Blobs of blue and swirls of bright green in a zig-zag horizontal stripe pattern. Hot pink background. Silk. French. 1968.

Lower left: The swirling serpentine stripes are softly muted. Notice the muted colors are bordered by darker, bolder colors, barely seen in this swatch. Very sheer silk. French. 1968.

Below: Very wide hatband stripes in off white, hot orange, and brown. Woven viscose rayon. Italian. 1968.

Top left: Camouflage-look design in taupe, pale blue, and navy. Silk. French. 1968.

Top right: Novelty stripe design in red, white, blue, and brown. Silk crepe de chine. Italian. 1967.

Lower left: Cool and bright greens in a horizontal zig-zag pattern interwoven with black vertical stripes. Loose patterned open weave cotton. French. 1966.

Lower right: Leaf shapes in a wavy modified stripe pattern. Hot pink, tangerine, green, and gray on maroon with black pin stripes. Polyester and rayon. French. 1969.

73

Top: Flower buds and scallop shape images in a stripe pattern. Hot pink, bright green, tangerine, and medium brown on white. Ribbed woven cotton. Italian. 1968.

Lower left: Hot orange and green stripes crossed by thin black lines to form a circuitry-effect design. Rayon acetate. French. 1968.

Lower right: Novelty stripes with scribbly lines. Mint green, jade green, navy, and white. Twill weave cotton. Italian. 1968.

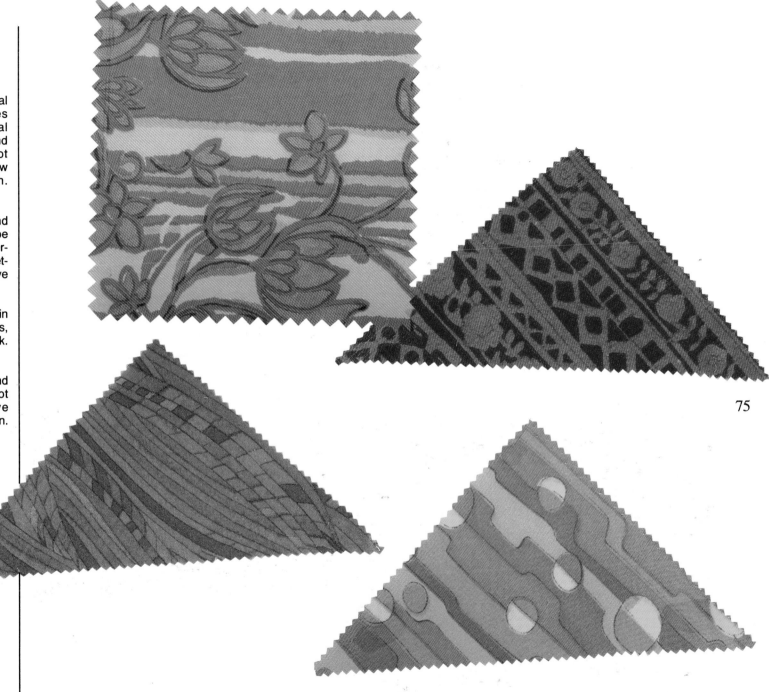

Top left: Outlined floral shapes gently curves over a bright vertical stripe pattern. Lilac and green florals over hot pink, orange, and yellow stripes. Silk. French. 1968.

Top right: Hot pink and purple in a novelty stripe pattern. The design alternates florals and geometric shapes. Loose weave rayon. Italian. 1968.

Lower left: Tiny bands in a flowing pattern. Blues, greens, brown, and pink. Wool. Italian. 1968.

Lower right: Circles and irregular stripes in hot pink, shades of olive green, yellow, and brown. Silk. Italian. 1968.

75

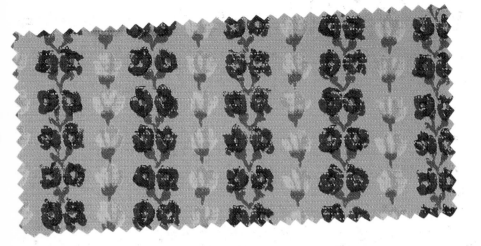

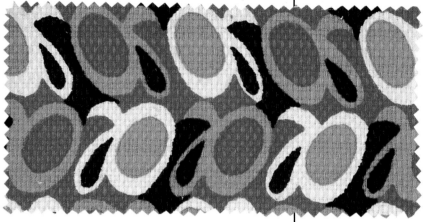

76

Top left: Floral stripe pattern in blue, yellow, and brown on pink. Textured cotton. Italian. 1966.

Top right: Egg and teardrop shapes. Hot orange, red, white, and navy. Basketweave cotton. Italian. 1968.

Far left: Novelty geometric shapes in a diamond check and stripe design. Red, blue, and green on bright purple. Wool fleece. Italian. 1967.

Lower right: Photograph of the larger fabric pattern.

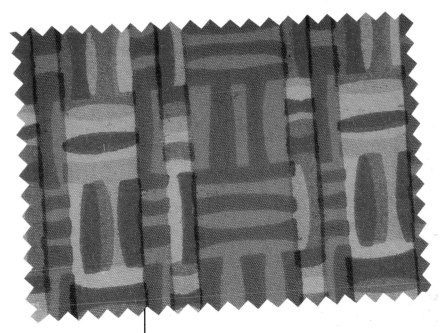

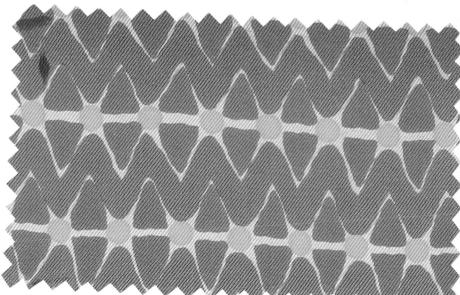

Top left: Basketweave-effect strokes in a bold stripe pattern. Hot pinks, and aqua blues. Silk shantung. French. 1968.

Top right: Rick-rack, triangles, stripes and dots visually create a diamond check pattern. Silk. French. 1968.

Lower left: Large and varied vertical wavy stripe pattern. Bright pink, fuchsia, orange, olive, and dark purple. Jersey knit of rayon and cotton. French. 1967.

Lower right: Pill shape design in a modified horizontal stripe layout. Light blue and bright blue with a mottled effect. Semi sheer, ribbed-look silk and rayon blend. French. 1967.

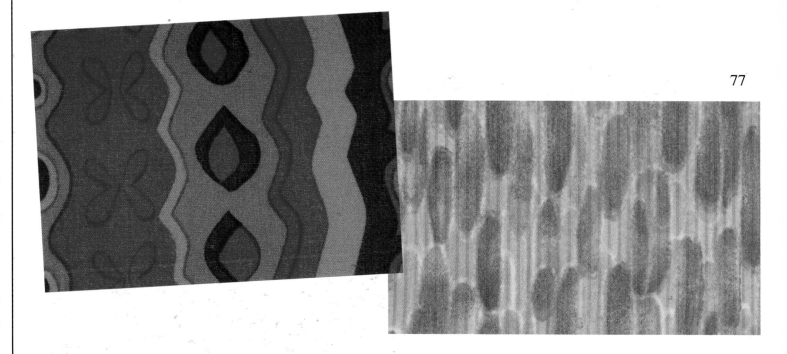

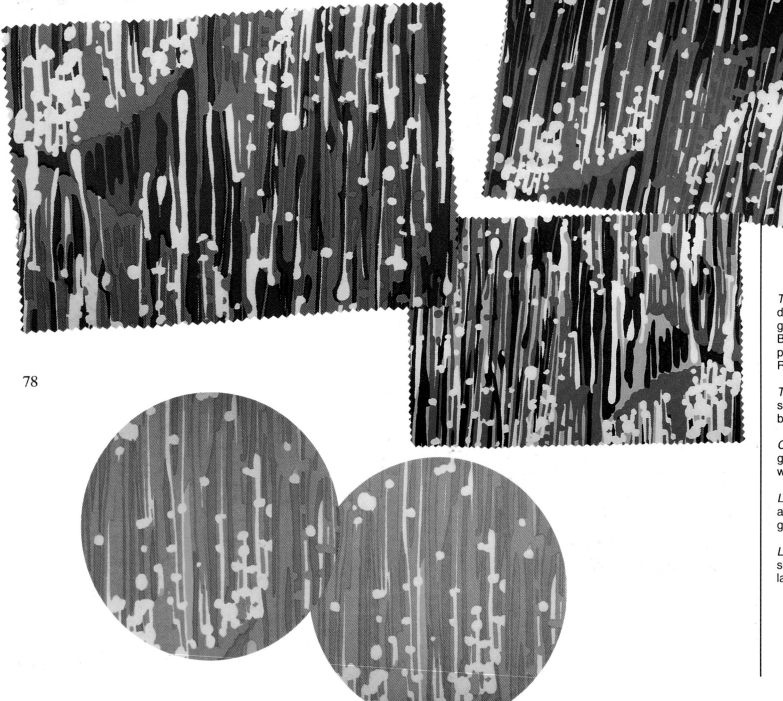

78

Top left: Confetti rain drops with the look of a glittery beaded curtain. Bright green, turquoise, purple, and white. Rayon. American. 1969.

Top right: Variation in shocking pink, red, brown, and white.

Center right: Variation in gold, red, navy, and white.

Lower left: Variation in aqua, lavender, lime green and white.

Lower right: Variation in shocking pink, orange, lilac, and white.

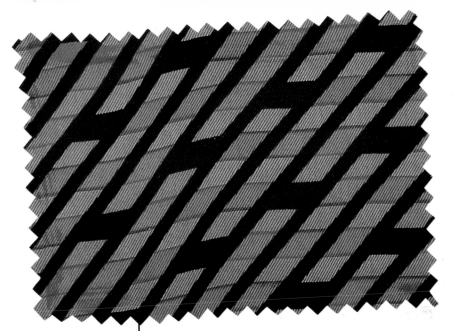

Top left: Interesting variation of a stripe pattern. Hot pink, coral pink, lime green, deep aqua, and black. Silk. French. 1968.

Top right: Petal shapes arranged in feather-effect horizontal stripe pattern. Soft yellow, bright yellow, aqua, purple, and brown. Rayon. French. 1968.

Lower left: Horizontal zigzag stripe pattern accented with serpentine stripes. Fabric background has metallic thread embroidery. Fuchsia, yellow, and black. Polyester, Lurex, and nylon backed with taffeta. French. 1969.

Lower right: Chevron weave-effect in a modified stripe pattern. Wool fleece. Italian. 1967.

80

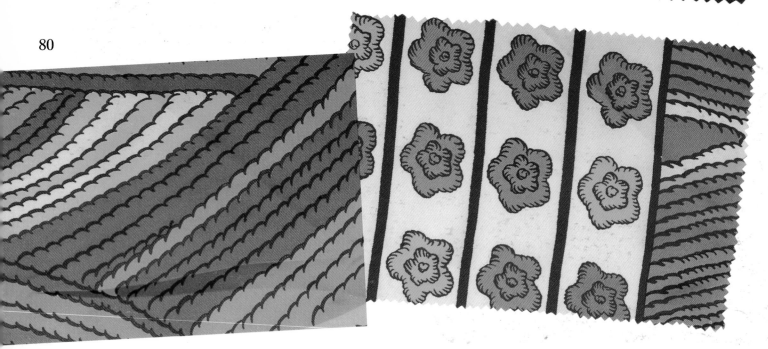

Top left: Mosaic pattern set in a wavy stripe design. Hot orange, hot pink, purple, blue, and green. Crinkly polyester and rayon. French. 1967.

Top right: Mosaic pattern set in a wavy stripe design using hot pink, red, wine, gold, and olive green. Acetate taffeta. French. 1968.

Lower left: Squiggle stripe pattern is the border design of a floral stripe print. Yellow, orange, coral-pink, green, purple, and white. Silk. American. 1968.

Lower right: The fabric in another color combination showing the floral stripe with the border. Hot pink, purple, chartreuse, and brown on white.

Top: Small undistinguishable shapes float in random fashion. Bright pink and yellow on light brown. Silk. French. 1967.

Lower left: Odd shapes set in a horizontal stripe pattern. Aqua, yellow, purple, and light gray on hot pink. Silk. French. 1968.

Lower right: Confetti-effect geometric shapes with an overall diagonal stripe effect. Yellow, purple, green, and blue. Silk. French. 1968.

GEOMETRIC
NOVELTY

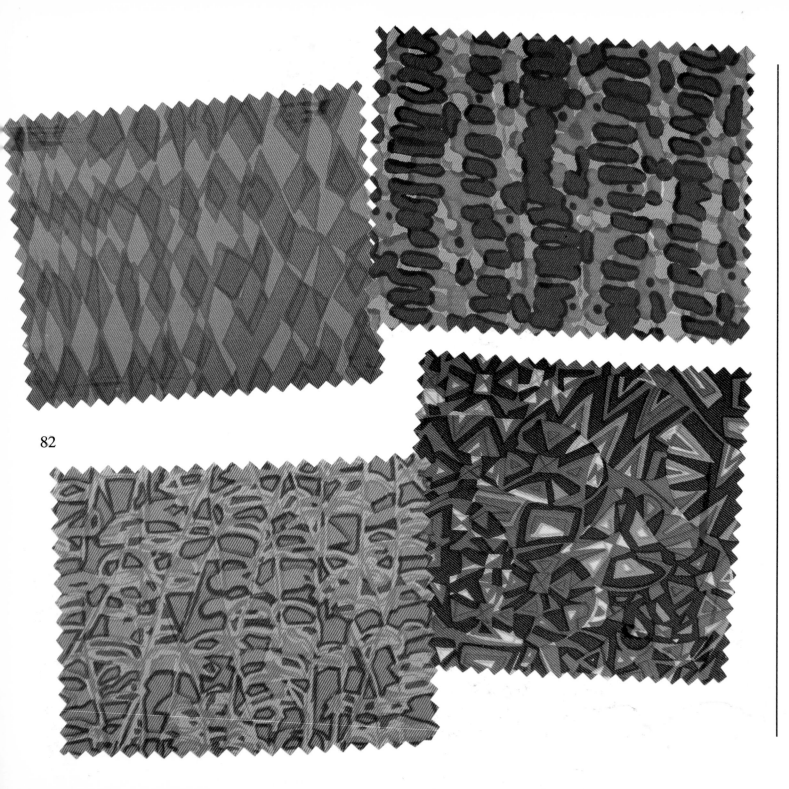

82

Top left: Modified harlequin check patter in five shades of green. Fine silk. French. 1968.

Top right: Abstract strokes form an overall vertical stripe pattern. Purple, and gold on rose pink. Rayon. French. 1968.

Lower left: Mesh-effect design in hot pink, yellow, orange, and purple on deep aqua. Silk. French. 1969.

Lower right: Small scale mosaic pattern in gold, periwinkle blue, lilac, bright green, and dark forest green. Silk. French. 1968.

Top: Abstract design in bold brush strokes. Hot orange, green, purple, and white. Silk. American. 1969.

Lower left: Variation in three tones of green.

Lower center: Variation in rose pink, hot pink, and fuchsia.

Lower right: Variation in aqua, turquoise, and peacock blue.

83

Top left: Randomly placed geometric shapes in an impressionistic design. Hot pink, orange, gold, and olive green on white. Rayon and linen. French. 1967.

Top right: Jumbled multicolor shapes in an open weave rayon and wool knit. French. 1969.

Below: Geometric circles and blobs in shocking pink, yellow, orange, sapphire blue, forest green, and white. Nubby textured rayon. Italian. 1968.

84

Top left: Scale-effect pattern in bright yellow, golden yellow, greens, blue, and white. Rayon taffeta. French. 1968.

Top right: Interlocking pieces resembling a jig-saw puzzle. Shocking pink, hot orange, lime green, emerald green, and gold outlined in black. Textured cotton and linen weave. French. 1967.

Lower left: Puzzle effect mosaic pattern in cool shades of pink, purple, blue, gold and green. Rayon. French. 1968.

Lower right: Puzzle effect mosaic pattern in hot colors. Hot pink, fuchsia, purple, orange, and yellow. Silk and rayon. French. 1968.

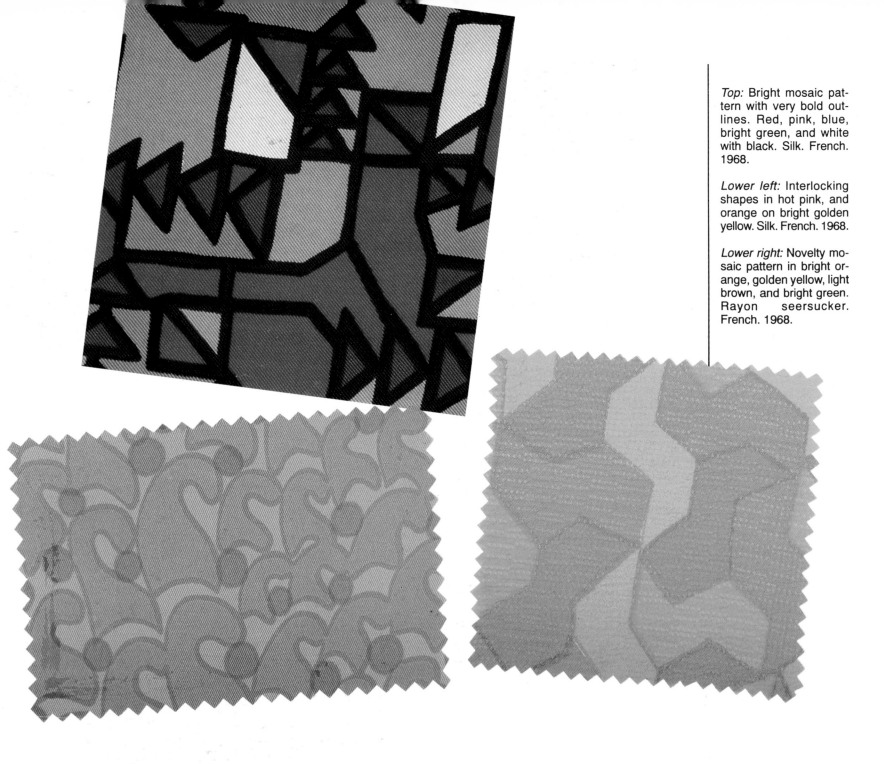

86

Top: Bright mosaic pattern with very bold outlines. Red, pink, blue, bright green, and white with black. Silk. French. 1968.

Lower left: Interlocking shapes in hot pink, and orange on bright golden yellow. Silk. French. 1968.

Lower right: Novelty mosaic pattern in bright orange, golden yellow, light brown, and bright green. Rayon seersucker. French. 1968.

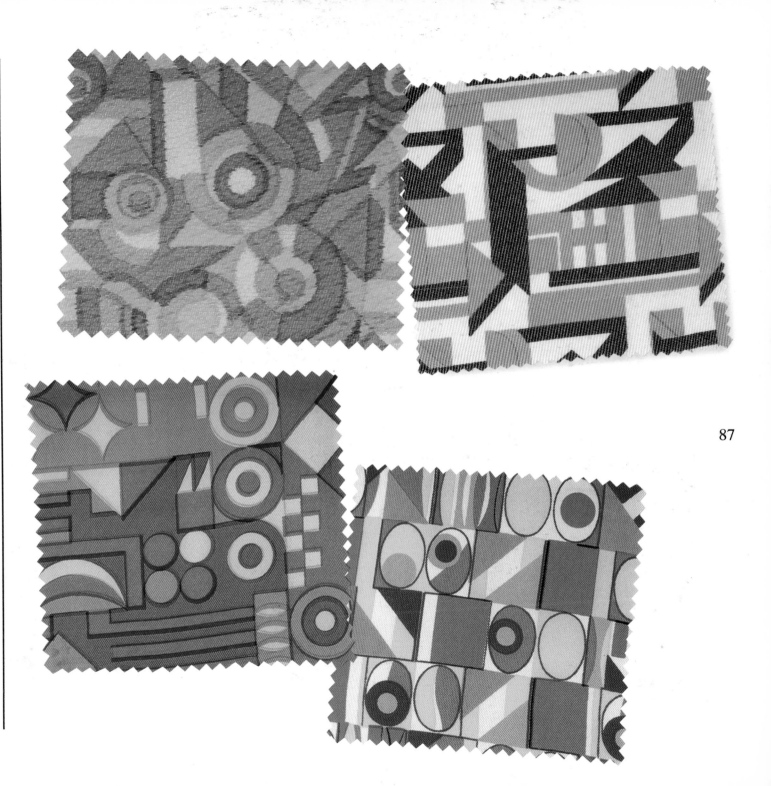

Top left: Geometric shapes in a jumbled pattern. Rose pink, hot pink, lilac, bright yellow, aqua, and lime green. Woven textured triacetate and polyester. French. 1968.

Top right: Varied geometric shapes in bright pink, bright green, and dark forest green on white. Cotton. French. 1967.

Lower left: Geometric shapes in primary colors. Silk. French. 1968.

Lower right: Boxes, circles, and ovals in a modified box layout. Hot pink, yellow, tangerine, orange, turquoise, purple, and white. Silk. 1968.

87

88

Top left: Picasso-inspired geometrics. Hot coral, deep rose pink, yellow, gold, green, deep aqua, light brown, and white. Arnel triacetate crepe. French. 1968.

Top right: Varied geometric shapes in bright yellow, orange-gold, green, and bright periwinkle blue. Polyester and rayon. French. 1968.

Lower center: Hexagons, octagons, and stars in a mosaic pattern. Fuchsia, purple, blue, and cherry red. Silk. French. 1968.

Below: Hexagons, octagons, and stars in a mosaic pattern. Hot orange, fuchsia, purple, and green. Rayon and triacetate. French. 1968.

Top left: Varied geometric shapes with a stained glass look. Pink, lavender-rose, tangerine, light blue, turquoise, emerald green, olive, and medium brown with black outline. Heavy open-weave cotton and linen. French. 1966.

Top right: Colorful shapes resembling building blocks. Hot orange, golden yellow, and bright yellow on fuchsia-pink. Rayon and silk. French. 1968.

Lower left: Fretwork and fan shapes in an Oriental-look design. Hot pink, lavender, aqua, and chartreuse. Silk. French. 1968.

Lower right: Mosaic-effect interpretation of flower buds. Hot orange, golden orange, lilac-pink, pale pink, and white. Triacetate crepe. French. 1968.

89

Top: Scattered fretwork in a starkly contrasting design. White, lavender-pink, and purple on black. Rayon. American. 1968.

Lower left: Tossed geometric shapes resembling playing jacks. Hot pink, aqua green, and blue on dark olive green. Silk. French. 1968.

Lower right: Randomly tossed boxes in hot pink, golden yellow, bright green, purple, and charcoal gray on tan. Silk. French. 1968.

90

Top: Stained glass look in soft but bright hues. Hot pink, aqua, lilac, and lime green bordered by dark olive green. Acetate jersey knit. French. 1968.

Lower left: Geometric shapes arranged in a semi-concentric pattern alternate with branch-like strokes to form a modified check pattern. Silk. French. 1968.

Lower right: Circles, squares, and triangles in a semi-set pattern. Semi-sheer triacetate. French. 1968.

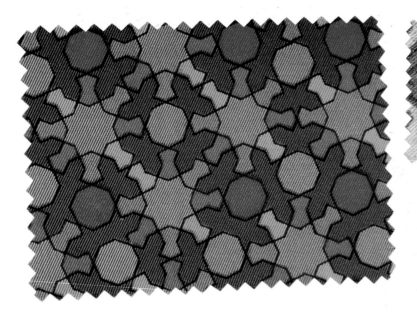

Top left: Stained glass look mosaic pattern. Hot pink, fuchsia, mint green, peacock blue, dark olive green, and white. Cotton knit. Italian. 1968.

Top right: The plank shapes in this design runs in a vertical pattern. Bright aqua blue and orange on lime green. Pinwale cotton corduroy. French. 1967.

Lower left: Various geometric shapes in a pattern resembling playing jacks. Hot pink, yellow, orange, and pale lavender on green. Rayon. French. 1968

Above: The Native-American motifs form a larger "rug" design. Dark aqua, purple, and burgundy on orange and yellow ground. Nubby textured linen and silk. French. 1969.

Top: Hot pink, tangerine, and white lends contrast to the dark mosaic-look pattern. Moss green, olive green, brown, and gray background. Cotton velour. Italian. 1969.

Lower left: A repeat pattern featuring tiny sunbursts and teardrop designs. Hot pink, mint green, yellow, orange, on off-white. Novelty weave silk and wool. French. 1968.

Lower right: Bullets and horseshoe shapes line up in a modified stripe design. Orange, deep fuchsia, and white on navy blue. Arnel acetate. French. 1968.

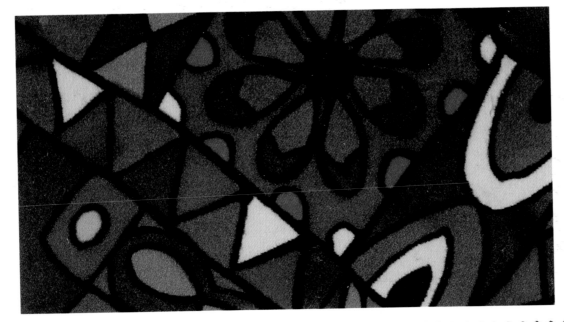

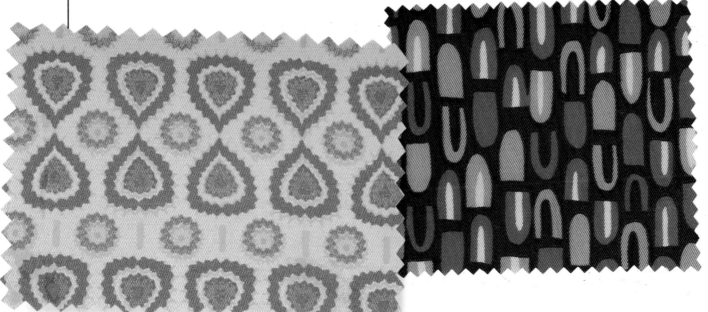

93

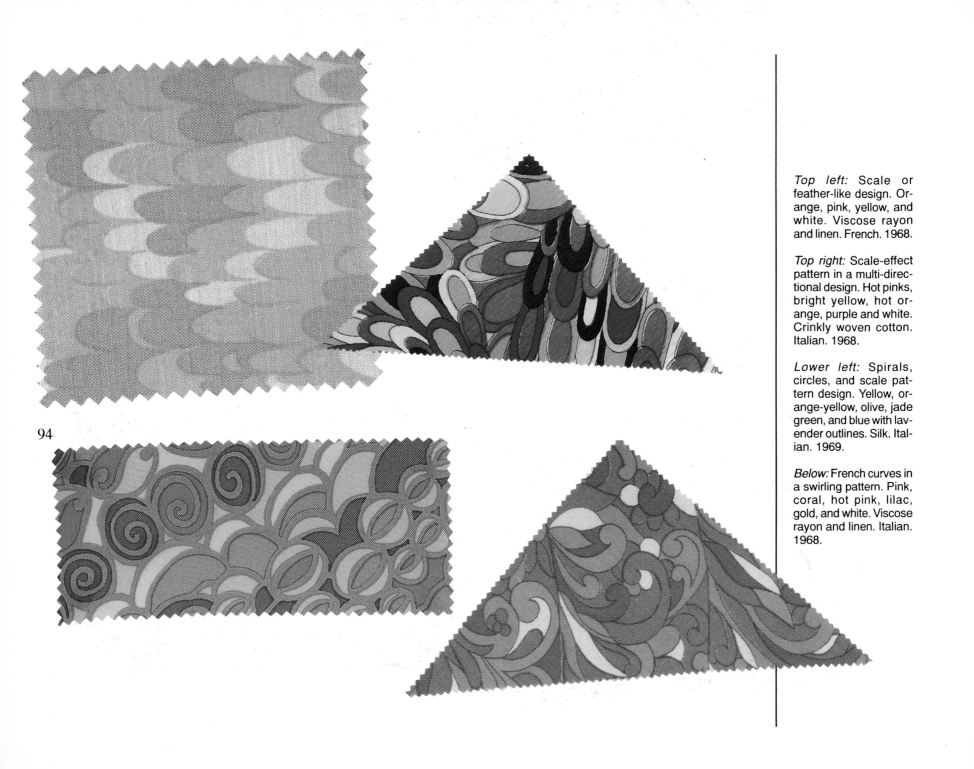

94

Top left: Scale or feather-like design. Orange, pink, yellow, and white. Viscose rayon and linen. French. 1968.

Top right: Scale-effect pattern in a multi-directional design. Hot pinks, bright yellow, hot orange, purple and white. Crinkly woven cotton. Italian. 1968.

Lower left: Spirals, circles, and scale pattern design. Yellow, orange-yellow, olive, jade green, and blue with lavender outlines. Silk. Italian. 1969.

Below: French curves in a swirling pattern. Pink, coral, hot pink, lilac, gold, and white. Viscose rayon and linen. Italian. 1968.

Top: Curving "S" shapes that could be the numerals 6 and 9 for the design year. Shocking pink, chartreuse, purple, and bright green on peacock blue. Triacetate. French. 1969.

Lower left: Looping laces in a swirling pattern. Pinks, orange, and gold. Wool and rayon knit. Italian. 1969.

Lower right: Paisley-look pattern in a shiny woven fabric. Hot pink, peach, gold, green, and blue. Viscose rayon and silver lamé. Italian. 1967.

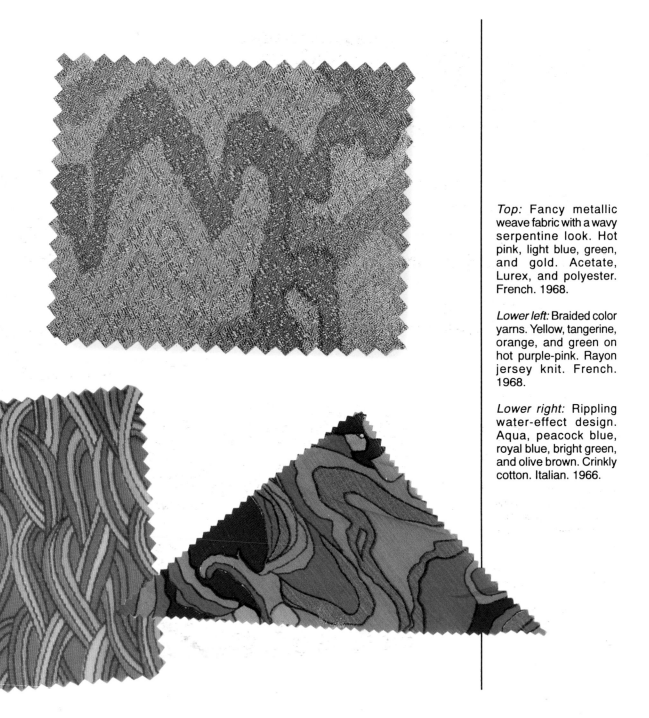

Top: Fancy metallic weave fabric with a wavy serpentine look. Hot pink, light blue, green, and gold. Acetate, Lurex, and polyester. French. 1968.

Lower left: Braided color yarns. Yellow, tangerine, orange, and green on hot purple-pink. Rayon jersey knit. French. 1968.

Lower right: Rippling water-effect design. Aqua, peacock blue, royal blue, bright green, and olive brown. Crinkly cotton. Italian. 1966.

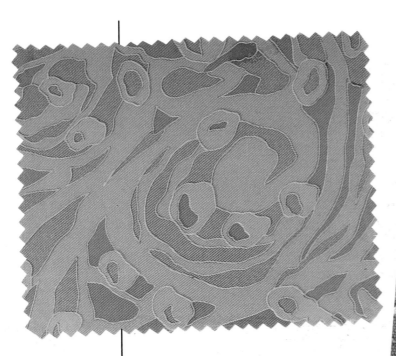

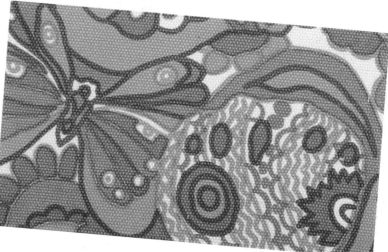

Top left: Swirling water-effect in refreshing cool hes. Chartreuse, purple-pink, green, and beige-gray on aqua. Silk. French. 1968.

Top right: Psychedelic butterflies. Orange, hot pink, purple-pink, and olive green on white. Tiny basketweave cotton. Italian. 1968.

Lower: Floral and other patterns in a twill weave cotton. Hot pink, bright green, blue, turquoise, and medium green. Italian. 1968.

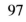

Top: Microscopic cell-look design in light rose pink, hot pink, lime green, jade green, aqua, and blue. Silk. Italian. 1969.

Lower left: Abstract designs with dots, curve lines, and spiral loops. Hot pink, hot orange, tan, khaki brown, and white on black. Rayon. American. 1968.

Lower right: Bright green, gold and brown shapes spaced on a three-toned pink mosaic tile-look pattern. Rayon plissé. French. 1968.

Top left: Flowers and geometric shapes. Light pink, hot pink, lime green, periwinkle blue, and olive green on orange-yellow. Cotton piqué. Italian. 1968. (use the transparency)

Top right: Patches of bright colors in an interesting fabric combining a raised cellophane leaf pattern weave and silk. Hot pink, peach, and golden yellow. Italian. 1967.

Lower left: Busy pattern with geometric shapes and daisy-like flowers. Fuchsia, golden yellow, green, brown and white on beige. Textured rayon. French. 1966.

Lower right: Honeycomb weave fabric in an abstract design. Hot pink, bright green, hot orange, and brown. Wool and rayon knit. Italian. 1967.

99

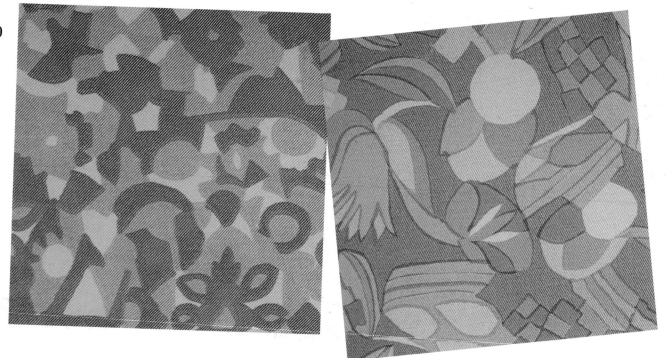

Top: Plaid-look design with intersecting lines. Note the novelty serpentine weave in the fabric. Neon orange, lavender, light pink, hot pink, lime green, and deep peacock blue. Woven cotton. Italian. 1968.

Lower left: Abstract design in cool blues, emerald green, and bright citrus green. Rayon and silk. French. 1968.

Lower right: Stylized florals in an abstract pattern. Bright tangerine orange, aqua, pale green, hot pinks, copper brown on moss green. Rayon and silk. French. 1968.

Top life: Shapes resembling highly stylized leaves and florals. Pale lavender, hot pink, bright green, and bright aqua blue. Rayon and silk. French. 1968.

Top right: Cellular shapes in a novelty check woven fabric. Hot pink, orange-yellow, warm gray on white. Cotton. Italian. 1968.

Lower left: Floating bands of ribbons. Blue, purple, taupe, brown, and bright orange. Woven of synthetic fibers and gold lamé. Italian. 1967.

Lower right: Novelty herringbone weave fabric with large graphic bands of color. Golden yellow, tan, lavender, moss green, mint green, teal, and olive green. Cotton. Italian. 1968.

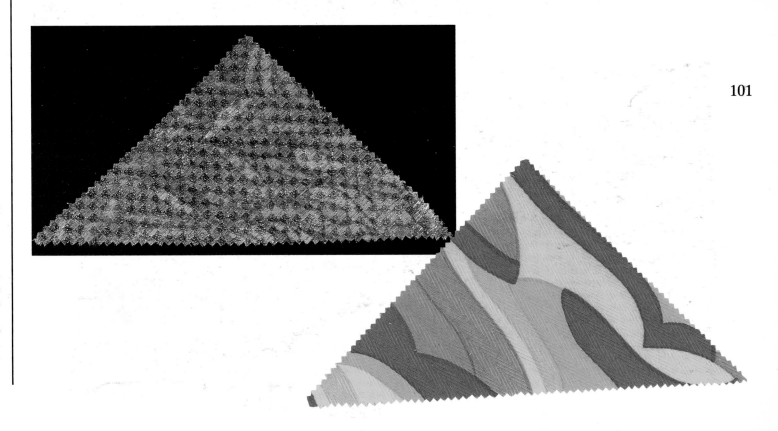

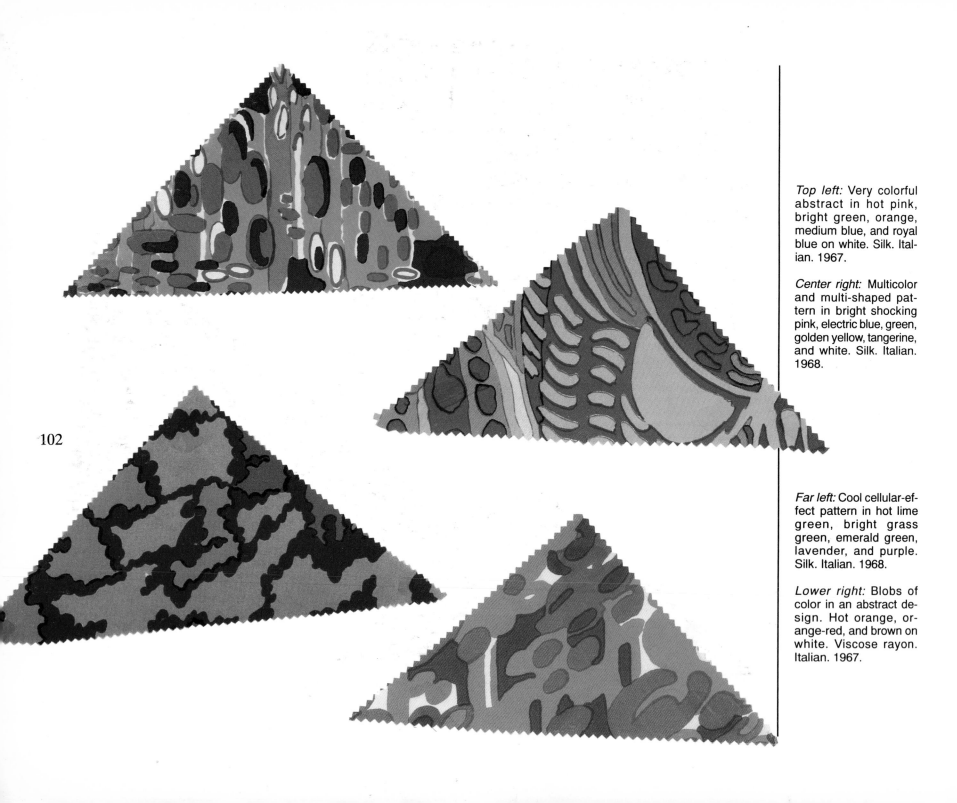

102

Top left: Very colorful abstract in hot pink, bright green, orange, medium blue, and royal blue on white. Silk. Italian. 1967.

Center right: Multicolor and multi-shaped pattern in bright shocking pink, electric blue, green, golden yellow, tangerine, and white. Silk. Italian. 1968.

Far left: Cool cellular-effect pattern in hot lime green, bright grass green, emerald green, lavender, and purple. Silk. Italian. 1968.

Lower right: Blobs of color in an abstract design. Hot orange, orange-red, and brown on white. Viscose rayon. Italian. 1967.

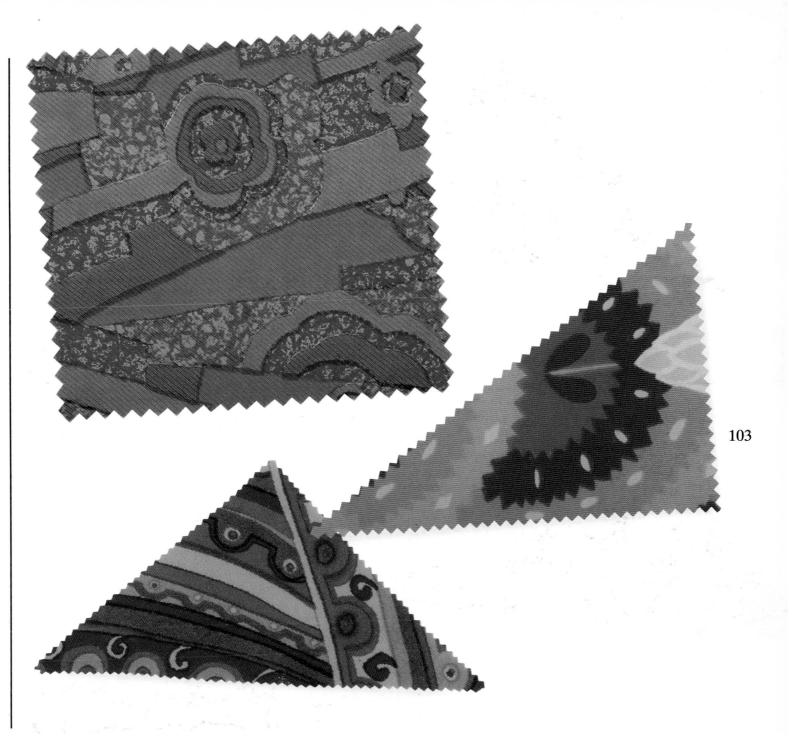

Top: Calico-look abstract floral design. Hot pink, red, green, periwinkle blue, and gray. Triacetate in a twill weave. French. 1968.

Far right: Abstract floral and leaf patterns in a whimsical design. Rayon. Italian. 1967.

Lower left: Design resembling architectural borders. Golden yellow, purple, electric blue, lime green, teal, and olive green. Wool knit. Italian. 1967.

103

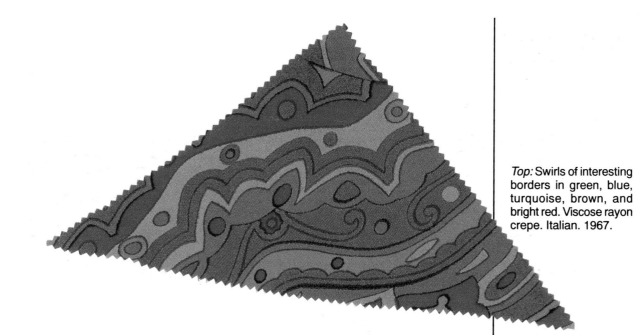

Top: Swirls of interesting borders in green, blue, turquoise, brown, and bright red. Viscose rayon crepe. Italian. 1967.

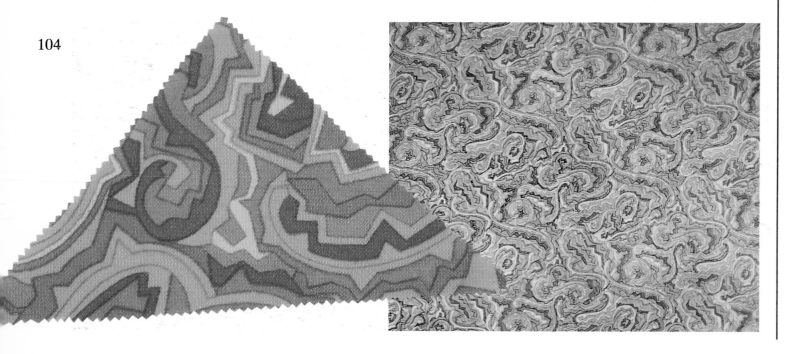

104

Lower left: Mosaic-effect pattern in a swirling design. Yellow, orange, red, green, brown, and purple. Wool knit. Italian. 1967.

Lower right: Photograph of the overall fabric design.

Top: French curves and various other shapes form this mosaic pattern. Textured wool knit. French. 1968.

Lower left: Mexican-look design in bright orange, hot pink, electric blue, brown, and white. Large images in the design. Textured woven viscose rayon. Italian. 1967.

Lower right: Photograph of the larger fabric swatch.

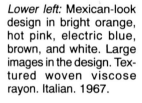

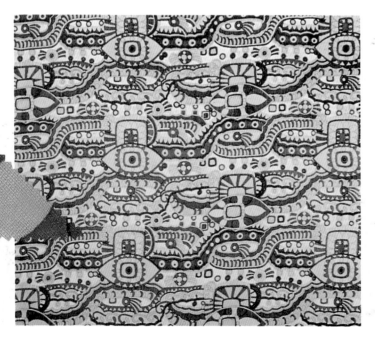

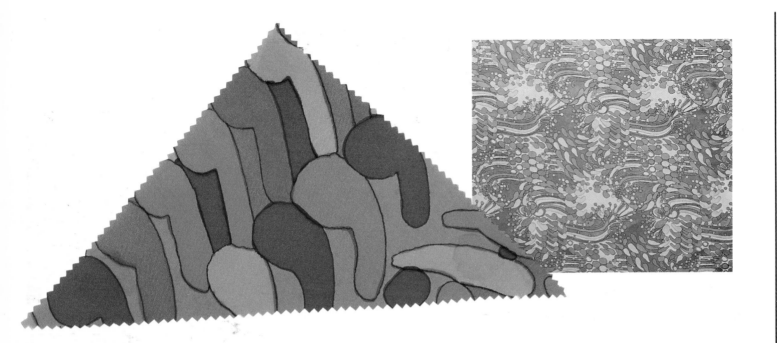

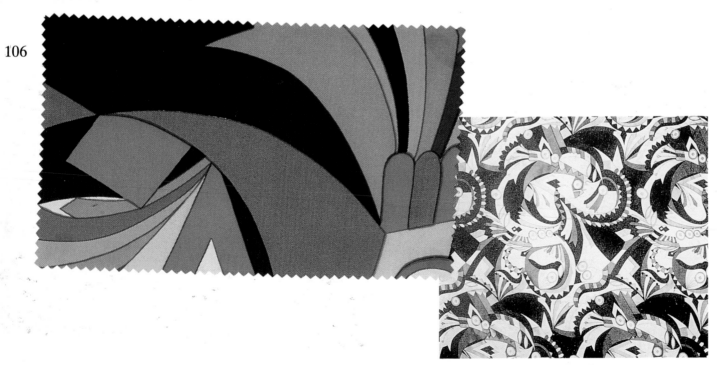

106

Top left: Comma shape images in a very colorful setting. Shocking pink, aqua, green, lilac, and khaki tan on hot pink. Silk. Italian. 1967.

Top right: Photograph of the overall fabric pattern reveals a Peter Max-look design with not only commas, but circles, balloons, rainbows, and paisley shapes.

Lower left: Picasso-inspired design in hot orange, neon green, deep aqua, blue, brown, green, and white. Silk. Italian. 1968.

Lower right: Photograph of the larger pattern.

Top left: Stylized florals in a Peter Max-inspired print. Orange, tangerine, peacock blue, chartreuse, taupe, and black. Silk crepe. Italian. 1968.

Top right: Photograph of the larger pattern.

Lower left: Tubes and pipes design. Hot pink, orange-red, yellow, tangerine, and green on dark teal blue. Cotton knit. Italian. 1967.

Lower right: Torn paper-look design in hot pink, lilac, deep aqua, blue, and spring green on dark navy ground. Silk. French. 1968.

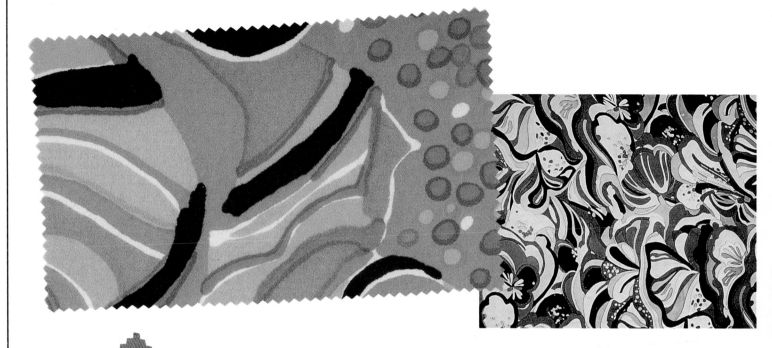

107

108

Top: Abstract shapes in shocking pink, red, sapphire blue, and black. Wool. Italian. 1968.

Lower left: Large cut out geometric shapes in a modernistic design. Pink, hot pink, bright yellow, orange, lime green, and purple. Silk. French. 1968.

Lower right: Orange and blue graphics. Twill weave cotton. Italian. 1968.

Top left: Large print featuring squares inside a diamond print. This fabric design was considered a double border print. The larger swatch has the same print scaled smaller to form the double stripe border. Pink and purple on white. Rayon. American. 1966.

Top right: Variation in blues.

Lower left: Large geometric circles and blocks in a border design. Pinks. red, and beige. Silk. American. 1967.

Lower right: Variation in purples and blues.

109

110

Picotage, or "pinning" effect is used in this abstract design accented by bold black brush stroke circles and dots. Orange, yellow, brown, and black on medium blue. Silk. French. 1967.

Top: Large poppies on a very large plaid pattern. Bright yellow with black outline on white. Rayon twill. American. 1966.

Lower left: Peter Max inspired print in a whimsical pattern of clouds and flowers. Reds and blues. American. 1968.

Lower right: Variation in purples and greens.

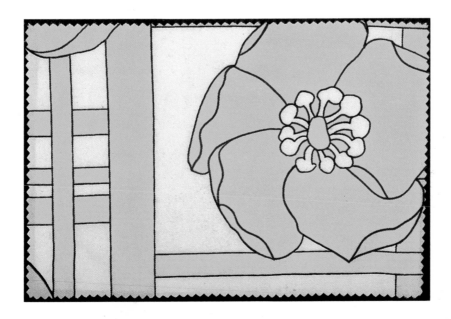

 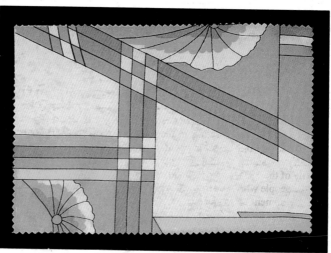

112

Top left: Another version of a double border design. A portion of the border is shown in the smaller spheres on the left. Shocking pink and beige on white. Rayon. American. 1968.

Top right: Variation in greens

Lower left: Frank Lloyd Wright-inspired stained glass design. Lilac, aqua, green, and blue on white. This fabric has a checkered blue and white double border. Silk. American. 1967.

Lower right: Variation in beige, peach, and orange.